NORWICH
IMAGES of America

Dale Plummer

Copyright © 2003 by Dale Plummer
ISBN 0-7385-3480-3

First published 2003

Published by Arcadia Publishing,
Charleston SC, Chicago IL, Portsmouth NH, San Francisco CA

Printed in Great Britain

Library of Congress Catalog Card Number: 2003111664

For all general information, contact Arcadia Publishing:
Telephone 843-853-2070
Fax 843-853-0044
E-mail sales@arcadiapublishing.com
For customer service and orders:
Toll-free 1-888-313-2665

Visit us on the Internet at www.arcadiapublishing.com

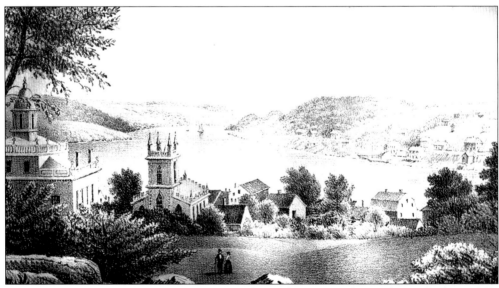

NORWICH CITY AND RIVER. This 1845 view shows the court and town house, built in 1829, on the left. The church building below the courthouse is Trinity Episcopal Church, a Gothic Revival building. On the west shore of the harbor, a vessel is being constructed. Shipbuilding was an important local industry. The first shipyard was established in 1694.

CONTENTS

Acknowledgments		6
Introduction		7
1.	The Rose of New England	9
2.	Industry	17
3.	Transportation	37
4.	A City of Villages	53
5.	Norwich at Play	77
6.	Business and Home	91
7.	Community Institutions	109
8.	Norwich Celebrations	121

ACKNOWLEDGMENTS

Three individuals have devoted countless hours to saving the legacy of Norwich for future generations: Diane A. Norman, head of the reference department at the Otis Library; Faith Jennings; and Rene L. Dugas Sr. of Taftville. Linda Summers, director of the Otis Library, and Cornell McNair and the rest of the staff at the library, have graciously cooperated. Thanks also are due Richard Sharpe, chairman of the historic district commission; Richard Hamar; and the staff at Arcadia Publishing.

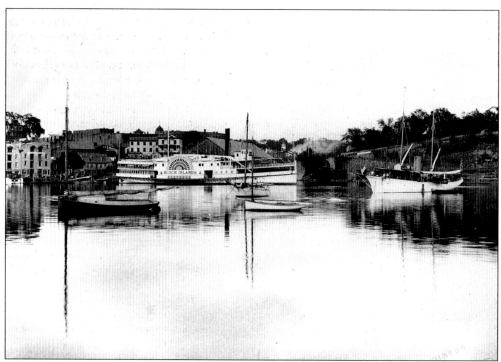

NORWICH HARBOR, 1898. The Osgood family yacht *Fadalma* is at the right. In the foreground are two catboats. (Courtesy the Otis Library.)

INTRODUCTION

Water dominates the history of Norwich. At the head of the Thames River, Norwich developed in the 1700s as an important Colonial seaport. Products of inland farms and forest were exchanged for goods from the West Indies, England, and Europe. But it was the force of falling water that transformed Norwich into a thriving manufacturing city in the 1800s. Waterpower drove the wheels of industry, providing employment for many and great wealth for some.

Yet Norwich was also a place of contradictions. The natural beauty of the landscape coexisted with the urge to make improvements on nature. Within its boundaries, both pastoral scenes and the smoke and noise of heavy industry were found. On its streets, descendants of old Yankee stock, Native Americans, African Americans, and more recent immigrants were seen.

In the century between the 1859 bicentennial and the 1959 tercentennial, Norwich prospered. While war, recession, floods, and fires occurred, the city continued to grow. Despite political wrangling, Norwich was a progressive city, embracing new concepts in government. Important civic amenities and improvements made life better for all the residents.

With a strong industrial past, Norwich has produced a bewildering variety of goods. The quality of workmanship was, in general, very high. Norwich products were shipped to markets across the country and abroad. The dominant local industry was textiles. Firearm manufacture, papermaking, metalwork, casting production, cabinet making, and woodworking were also engaged in.

The demands of industry outstripped available waterpower and labor resources. In the era after the Civil War, coal was brought in over the city's wharves to supplement waterpower. Area mills adapted new technology readily. This willingness to adapt to changing conditions slowed but did not halt the loss of industry in the 20th century.

Growing numbers of immigrants joined the local work force in the late 19th and early 20th centuries. Many were Roman Catholic, in contrast to the staunch Protestantism of mill owners. Affiliating with the Democratic party, they clashed with Republicans over issues such as temperance.

Division between the various sections of Norwich further complicated local politics. The manufacturing villages along the rivers maintained their own distinct character and identity. The rivalry between Norwichtown and the downtown continued. Yet the city found a way to work through differences.

The result is a history surprisingly rich and complex for a small city. It is my hope to have captured something of the splendor of Norwich's past.

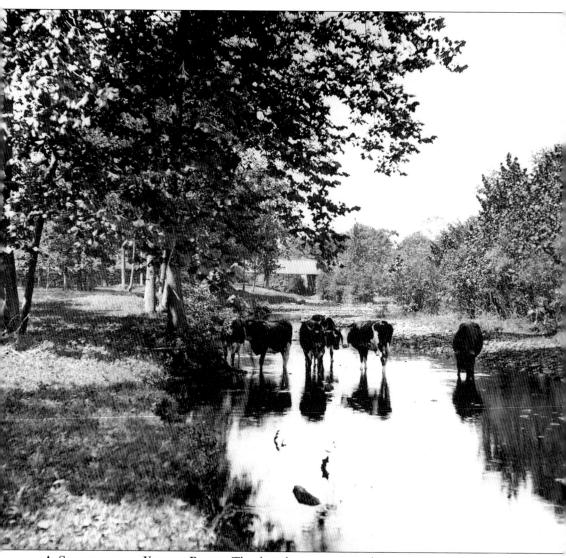

A SCENE ON THE YANTIC RIVER. This bucolic scene is on the upper reaches of the Yantic River. (Courtesy the Otis Library.)

One
THE ROSE OF NEW ENGLAND

In 1859, as Norwich prepared to celebrate the 200th anniversary of its founding, self-styled gentleman James Lloyd Greene suggested the title "the Rose of New England" for the city. Prosperity from manufacturing and trade had transformed a Colonial town to a Victorian city. Mansions lined the streets leading to the downtown. New homes and commercial buildings in the latest styles by local architects and builders testified to the taste and wealth of the city's residents.

Little more than a month after the parades and feasting were over, John Brown led a small force to seize the federal arsenal at Harpers Ferry, Virginia. One of his men, Aaron Dwight Stevens, was the son of the choirmaster at the First Congregational Church in Norwichtown. The raid on Harpers Ferry precipitated the growing conflict between North and South into war.

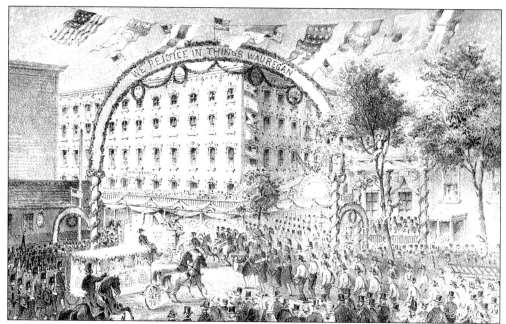

THE PROCESSION PASSING THE WAUREGAN. Volunteer fire units and the militia pass in front of the Wauregan Hotel. In the Mohegan language, Wauregan meant anything especially fine or good. (Courtesy the Otis Library.)

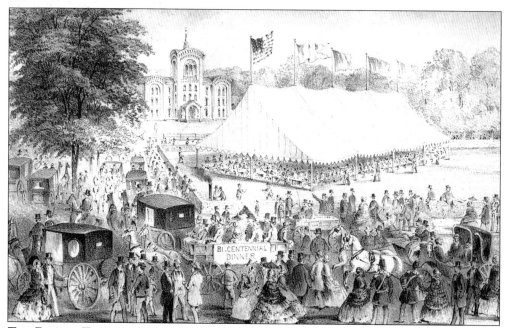

THE DINNER TENT IN FRONT OF THE FREE ACADEMY. Separate tents nearby were used for speakers. Caterer John T. Raymond prepared 48 dishes for more than 2,000 guests. (Courtesy the Otis Library.)

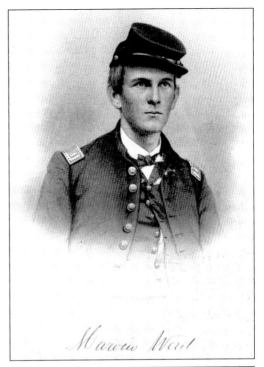

LT. MARVIN WAIT. A Democrat, attorney John T. Wait voted for Stephen Douglas, Abraham Lincoln's opponent, in the presidential election of 1860. When war broke out, however, he supported the Union cause. His only son, Marvin Wait, a college student, enlisted. Promoted quickly to lieutenant in the 8th Connecticut Volunteers, young Wait was wounded twice while leading his men in the bloody battle of Antietam. As he lay wounded, a fatal shot pierced his lungs. At 19 years of age, he was the first Norwich officer killed in the Civil War. His funeral was attended by the mayor, city council, and many citizens. The Norwich Light Infantry performed military honors. The stone is marked with the insignia of the signal corps. The epitaph reads, "He died with his young fame about him for a shroud." (Above, courtesy the Otis Library; right, photograph by the author.)

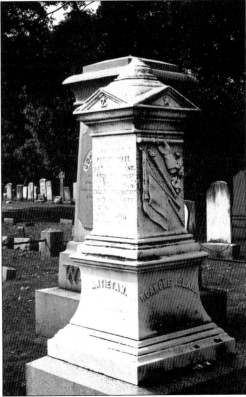

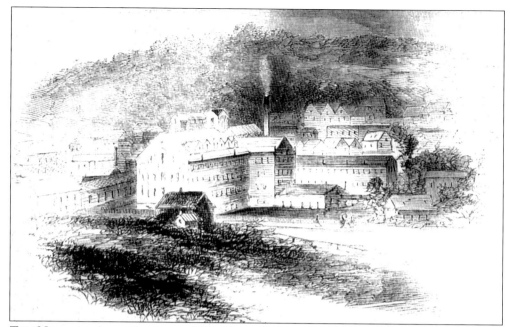

THE NORWICH ARMS COMPANY. "The Norwich Arms Co. was stimulated into existence by the war, and soon grew into gigantic proportions, filling successive contracts and furnishing large supplies of musketry for the Government," said author and historian Frances M. Caulkins in 1866. (Courtesy the Otis Library.)

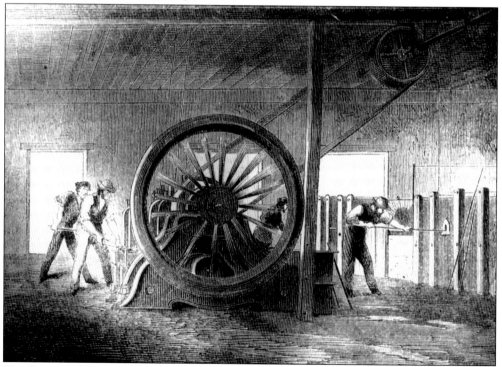

THE ROLLING MILL. Here, white-hot plates of iron called scalps were rolled into musket barrels. A ten-pound scalp was reduced to seven pounds in this process. (Courtesy the Otis Library.)

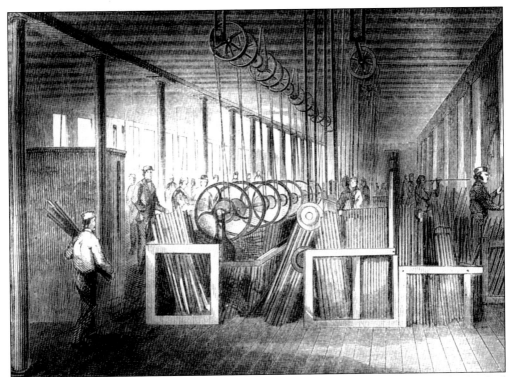

THE BARREL ROOM. The musket barrel was bored true and rifled. After grinding, the finished weight of the barrel was four and a half pounds. (Courtesy the Otis Library.)

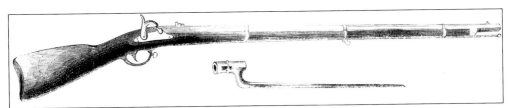

A MUSKET AND BAYONET. The total weight of the finished musket was almost 10 pounds. The government paid $20 for each musket made. The use of more accurate rifled guns with a longer range was responsible for the terrible carnage on Civil War battlefields. (Courtesy the Otis Library.)

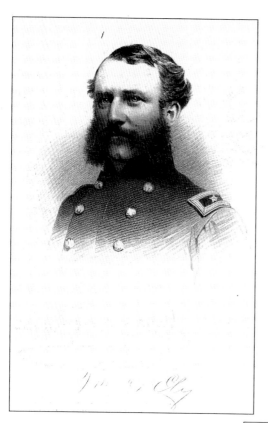

COL. WILLIAM G. ELY. The 18th Regiment Connecticut Volunteer Infantry was made up primarily of officers and men from Norwich and its vicinity. At the Battle of Winchester, Virginia, on June 13–15, 1863, the entire regiment was captured. Confined in Libby Prison, William G. Ely escaped only to be recaptured. He was later released and returned to his regiment, which he led in the Union victory at Piedmont. Following the war, Ely, promoted to brigadier general, was a cotton manufacturer. (Courtesy the Otis Library.)

SEN. LAFAYETTE S. FOSTER. Born to a poor farm family in the neighboring town of Franklin, Foster graduated from Brown University in 1828 and began his legal career under Norwich attorney Calvin Goddard. In 1837, he married Joanna Boylston Lanman, whose father had been a Connecticut Supreme Court judge and U.S. senator. Foster served six terms in the state legislature. In 1854, he was elected to the U.S. Senate. During his second term, he was elected president pro tempore of the Senate on March 6, 1865. On April 15, 1865, Pres. Abraham Lincoln died from an assassin's bullet. Foster, by the rules of succession, became the acting vice president of the United States. (Courtesy the Otis Library.)

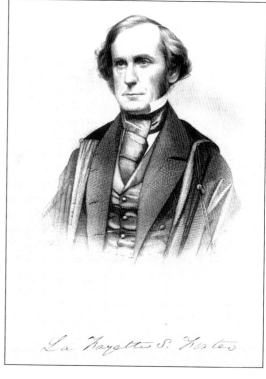

GOV. WILLIAM A. BUCKINGHAM. Born in nearby Lebanon in 1804, William A. Buckingham moved to Norwich as a young man. He reinvested profits from a dry goods store into rubber manufacturing. As president of the Norwich Hotel Corporation, he was responsible for the building of the Wauregan Hotel. He was elected mayor of Norwich twice, in 1849 and 1856. On the Republican ticket, he was elected governor of Connecticut in 1858, serving eight consecutive one-year terms. He was the only state governor to be in office for the entire Civil War. Buckingham supported the emancipation of slaves as a moral duty as well as a military necessity. In 1868, he was elected to the U.S. Senate. He died in 1875. (Courtesy the Otis Library.)

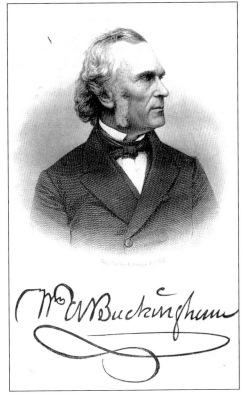

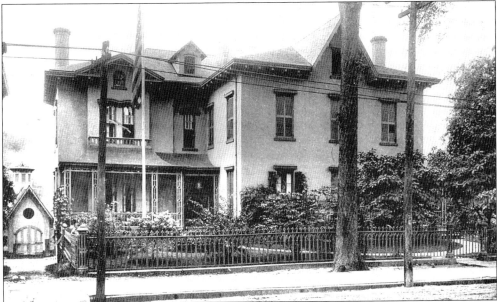

THE BUCKINGHAM MEMORIAL. Built in 1847, the Italianate mansion of Gov. William A Buckingham was acquired by a Union veterans group, Sedgwick Post No. 1, Grand Army of the Republic. Veterans, many of whom voted Republican, exerted considerable political power. Local political leaders worked hard to resolve pension and benefit issues for the veterans and their families. (Courtesy the Otis Library.)

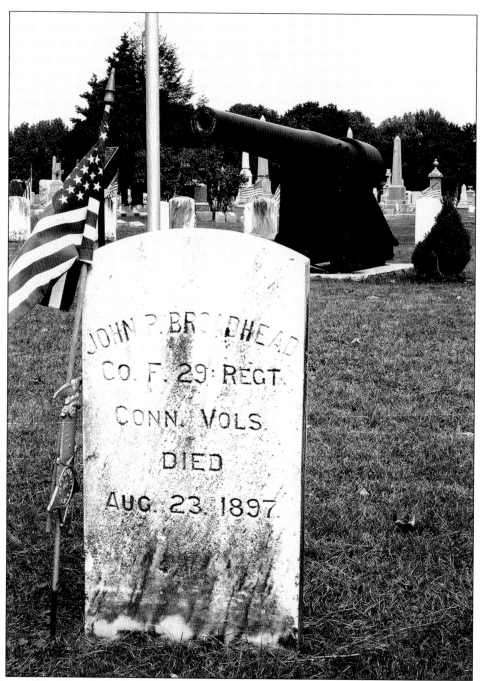

CIVIL WAR GRAVES, YANTIC CEMETERY. This circle of graves surrounds a 30-pound Parrott rifle at Yantic Cemetery. Seven of the graves are those of Union prisoners who died at the Confederate prison camp at Andersonville, Georgia. Their bodies were exhumed and returned to Norwich for burial. One young man from Norwich at Andersonville wrote in his diary, "At times, I fancy I hear the church bells in Norwich." The grave in the foreground is that of John P. Broadhead, an African American who served in the 29th Connecticut Volunteer Infantry. (Photograph by the author.)

Two
INDUSTRY

The Thames River is formed by the junction of the Yantic and Shetucket Rivers at Norwich Harbor. The Yantic, on the west side of the harbor, was navigable to the base of the falls. Seagoing vessels could discharge and load cargos here. The height and steepness of the falls led to the use of waterpower at this site as early as the 1660s, when miller John Elderkin set up a gristmill at the foot of the falls. From the falls, industry spread upriver. The low rate of flow of the Yantic and its periodic dry spells led to the introduction of steam power to supplement that of falling water. Industrial development spread outward from its beginnings at the falls. Favorable sites on the Yantic were soon exhausted, and development spread up the Shetucket River and its tributaries.

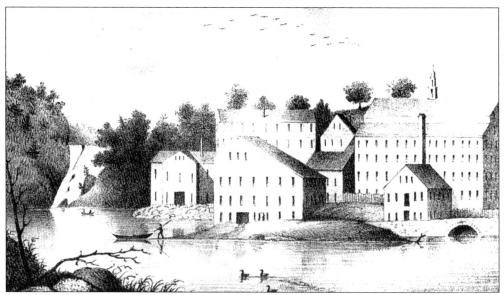

NORWICH FALLS. In 1866, historian Frances M. Caulkins stated, "The Water-Fall at this place was formerly regarded as one of the most interesting natural curiosities in this part of the country. So much of the stream has been diverted from its original headlong course over the parapet of rocks, for mechanical uses, that the description given of the cataract sixty years ago seems exaggerated. It is only at the spring floods, when the swollen river comes roaring through the chasm, filling the channel from side to side, that we can realize the old picturesque grandeur of the scene." (Courtesy the Otis Library.)

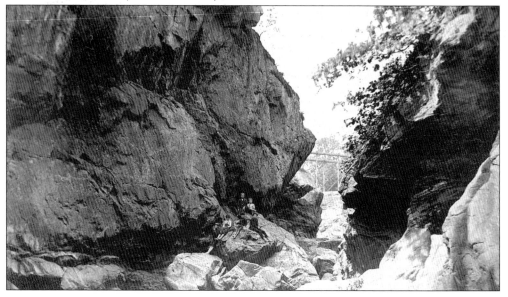

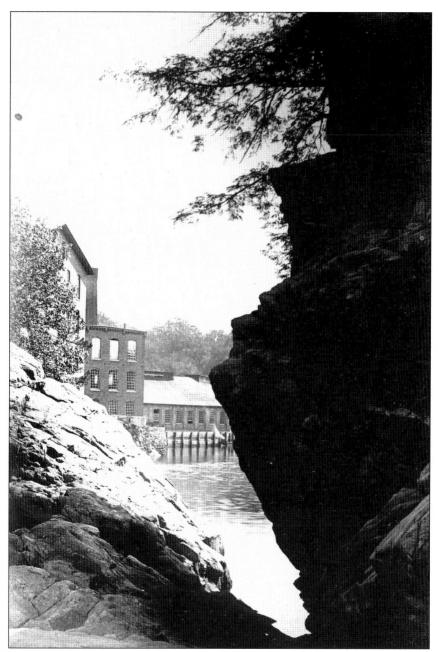

THE FALLS MILLS SEEN FROM THE CHASM. In 1866, historian Frances M. Caulkins stated, "Business, population and machinery are gradually winding their way, guided by noisy streams, into the secluded haunts of the neighborhood, and eating out the heart of our most picturesque scenery. But this is a cause for congratulation, and not for complaint. The dash of falling waters, the songs of birds, and the roar of winds among the trees of the forest, may be more pleasing to the ear and imagination than the thunder and clang of looms and wheels, yet it is a part of the mission of objects of taste to yield gracefully to those imperative interests that provide occupation for industry, markets for farmers, and comfortable homes for the multitude." (Courtesy the Otis Library.)

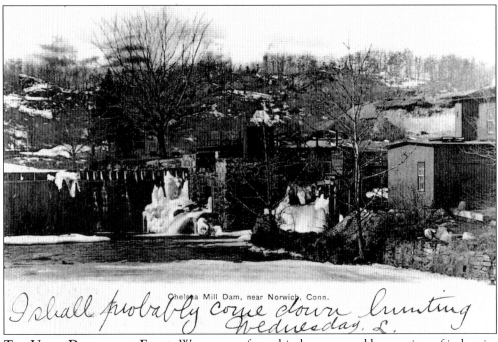

Chelsea Mill Dam, near Norwich, Conn.

I shall probably come down hunting Wednesday. L.

THE UPPER DAM AT THE FALLS. Waterpower from this dam was used by a variety of industries in the 18th century, including a woolen mill, pistol maker, file works, spool manufacturer, and braiding operation. The Falls Company eventually closed these down and built a small hydroelectric plant here *c.* 1901. (Courtesy the Otis Library.)

MANUFACTURERS' ADVERTISEMENTS, 1888. Chelsea files were made at the upper dam of the falls. (Courtesy the Otis Library.)

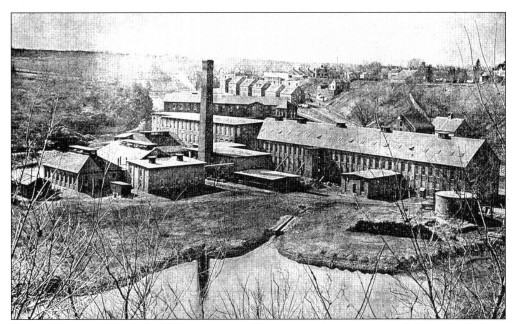

FALLS MILLS, 1888. Falls Mills was vertically integrated: cotton passed from the bale to finished cloth here. Bleaching and dyeing were done at the mill. Worker housing is located uphill from the mill. (Courtesy the Otis Library.)

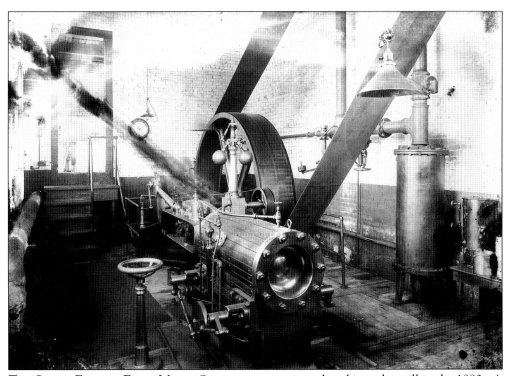

THE STEAM ENGINE, FALLS MILLS. Steam power was introduced into the mill in the 1880s. A single cylinder with a piston drives the enormous flywheel. The flyball governor on top of the cylinder regulates the flow of steam. (Courtesy Faith Jennings.)

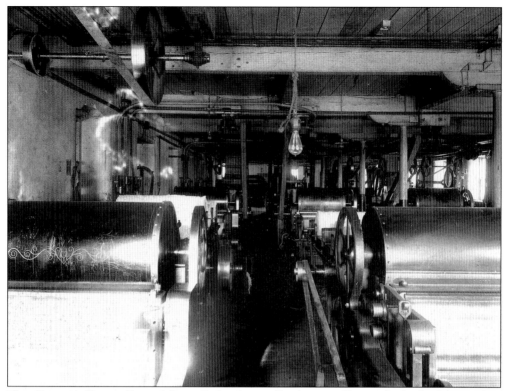

THE CARDING ROOM, FALLS MILLS. Picker laps, rolls of cotton fiber at the back of the carding machine, are fed into the machine, coming out as sliver at the front, not visible here. (Courtesy Faith Jennings.)

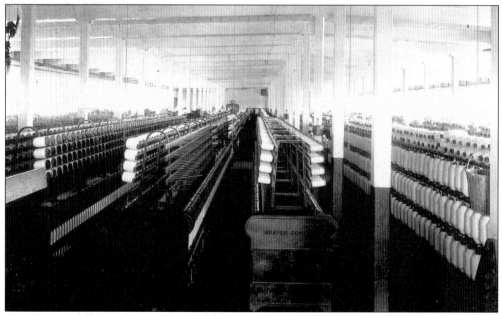

THE SPINNING ROOM, FALLS MILLS. After several intermediate stages, the cotton, now spools of roving, is spun into yarn. (Courtesy Faith Jennings.)

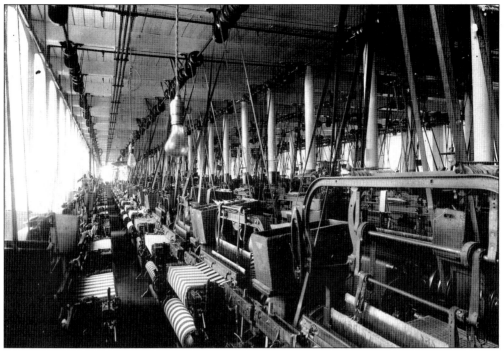

THE WEAVING ROOM, FALLS MILLS. Here, the yarn is woven into fabric. Some of the yarn has been dyed to create stripes in the fabric. (Courtesy Faith Jennings.)

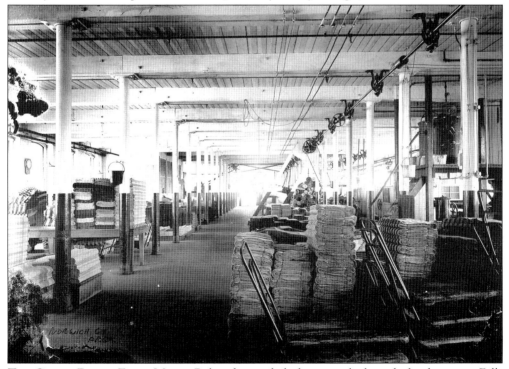

THE CLOTH ROOM, FALLS MILLS. Bolts of striped cloth are stacked, ready for shipment. Falls Mills specialized in awning cloth for storefronts. (Courtesy Faith Jennings.)

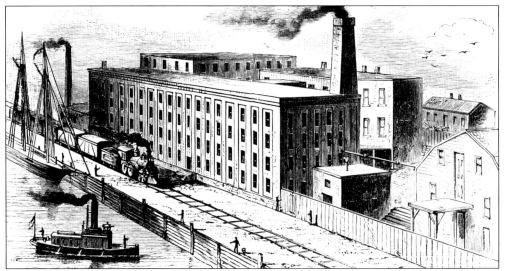

C.B. ROGERS & COMPANY. Caleb B. Rogers founded this company in 1846 to manufacture woodworking machinery. It was incorporated in 1863. Located on the west bank of the Thames River, the factory had both rail and water access. Machinery made here was shipped to various parts of the country, as well as to South America, Mexico, New Zealand, Australia, and Europe. (Courtesy the Otis Library.)

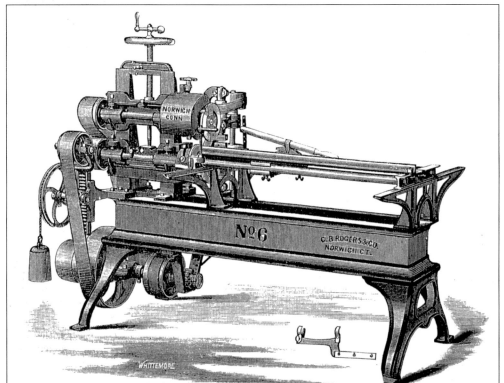

THE NO. 6 IRON FRAME TENON MACHINE, 1883. Weighing 1,100 pounds, this machine at C.B. Rogers & Company was designed to cut tenons for the manufacture of doors, window sash, and blinds. A three-inch tenon could be cut. (Courtesy the Otis Library.)

THE NO. 9 CAR MORTISING MACHINE, 1883. This machine at C.B. Rogers & Company was designed to cut mortises for the framework of railroad cars and bridges. It had an eight-inch stroke and weighed 3,700 pounds. Consolidation and expansion of railroads in the 1880s created demand for this type of machinery. (Courtesy the Otis Library.)

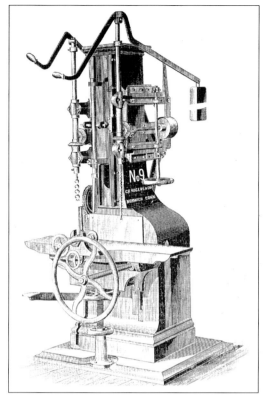

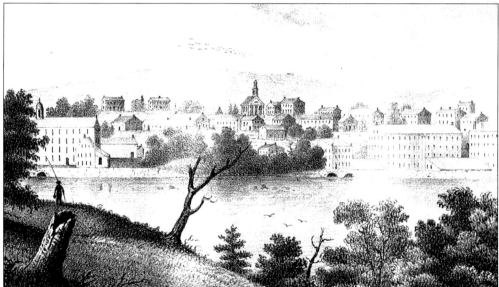

A VIEW OF GREENEVILLE FROM PRESTON, 1845. Greeneville was named for William P. Greene, the principal investor in the Norwich Water Power Company. In 1828, Greene and his partners purchased land and began construction of a dam and power canal along the Shetucket River. Industrial sites and waterpower along the canal were leased to companies making cotton cloth, axe handles, flour, and other products. Greeneville was a dry village; no alcohol was to be sold or dispensed there.

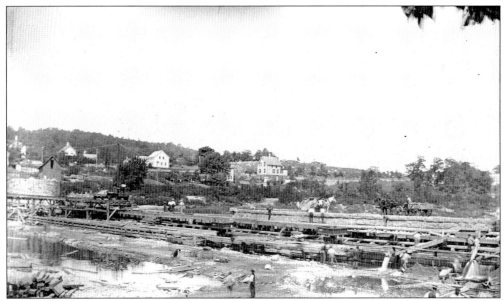

CONSTRUCTION OF THE NEW DAM AT GREENEVILLE, 1887. By the 1880s, demand for waterpower by industry had increased. A new dam was built downriver of the 1828 dam to raise the available head. The old dam was partially disassembled and then flooded by the rising waters of the new impoundment. (Courtesy the Otis Library.)

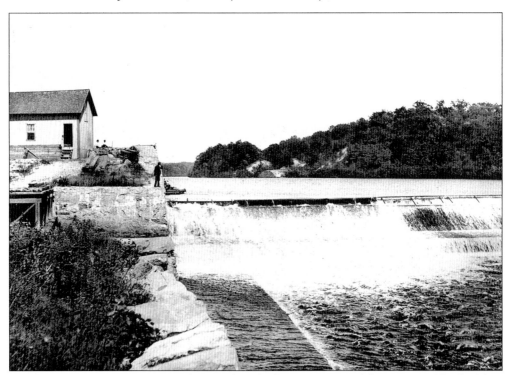

THE GREENEVILLE DAM, 1898. The new dam, built in 1887, is in full operation. The building to the left is the head house, containing the machinery to regulate the flow of water into the power canal by raising and lowering gates. (Courtesy the Otis Library.)

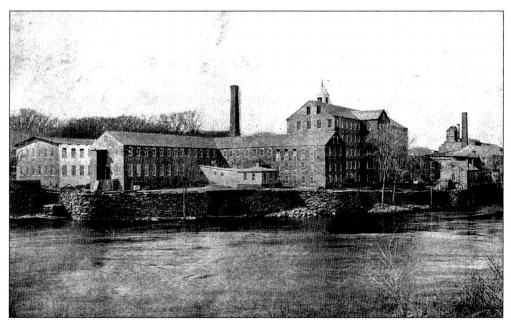

THE SHETUCKET COMPANY, 1888. Founded by William P. Greene, the Shetucket Company made cotton cloth. In 1888, it was reported that 500 workers produced 6 million yards of cloth a year here. The company also owned rental housing in the village of Greeneville. (Courtesy the Otis Library.)

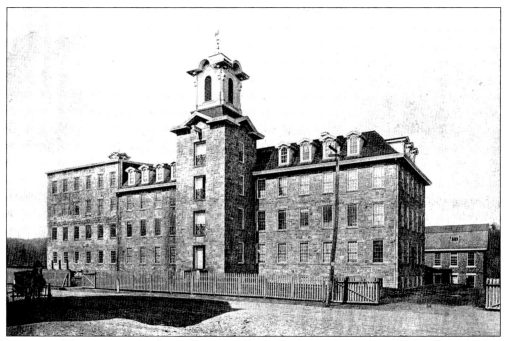

TOTOKET MILL, 1888. At this mill on the Shetucket River at Occum, 250 hands worked to produce 3 million yards of fine cotton sheeting yearly by 1888. Originally built as a woolen mill in 1864, by 1888, it was owned by Lorenzo Blackstone and had been converted to a cotton mill operated by his sons. (Courtesy the Otis Library.)

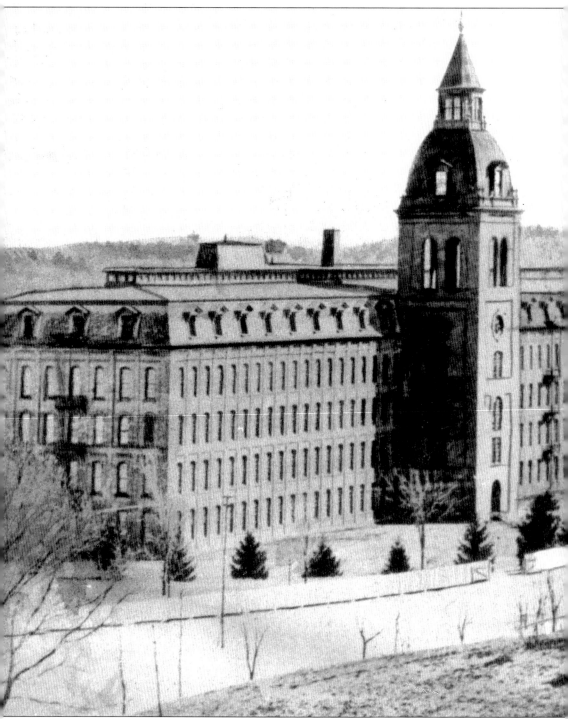

PONEMAH MILL, 1886. Spurred by the demand for luxury goods following the hardship of the Civil War years, work began on the giant mill and its dam in 1866. Five years later, the first machinery went into operation. Said to be the largest cotton mill under one roof in the United States, if not the world, Ponemah specialized in spinning and weaving fine cotton cloth from

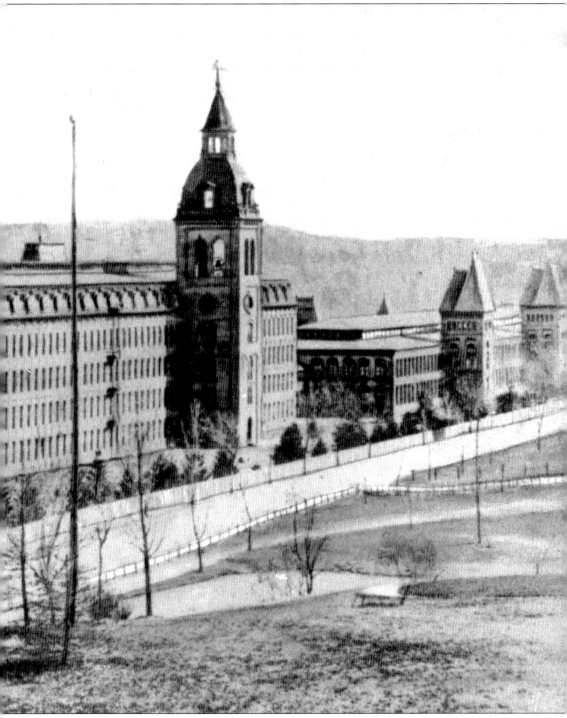

Egyptian cotton. A pound of cotton, it was boasted, could be spun into a 100-mile length of yarn. The total yardage of cloth manufactured in a year was enough to stretch halfway around the world. The mill employed some 1,500 workers. (Courtesy Rene L. Dugas Sr., photograph by Prime Dugas.)

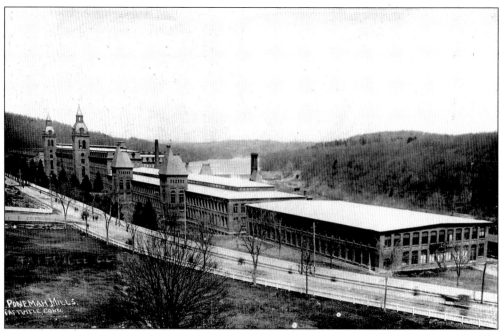

PONEMAH MILL, C. 1902. The original mill, completed in 1871, is at the far end. It was driven entirely by waterpower. Mill No. 2, finished in 1884 and powered by steam, is in the center. Mill No. 3, at the southern end, was powered by electricity. The entire complex extended about a third of mile and was connected by flying bridges between each mill. (Courtesy Rene L. Dugas Sr.)

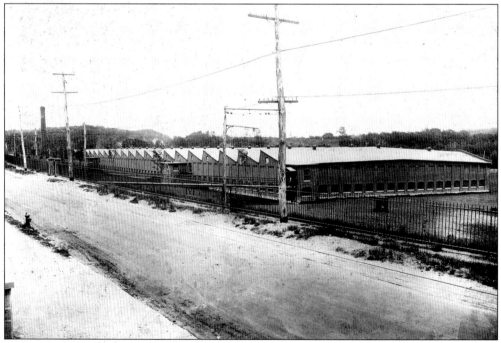

MILL NO. 4, 1910. The last addition to the Ponemah Mill complex was this enormous weave shed, measuring 700 by 200 feet. The sawtooth roof had north-facing windows. (Courtesy Rene L. Dugas Sr.)

THE INTERIOR OF MILL NO. 4. More than 3,000 looms produced fabric in the mill. (Courtesy Rene L. Dugas Sr.)

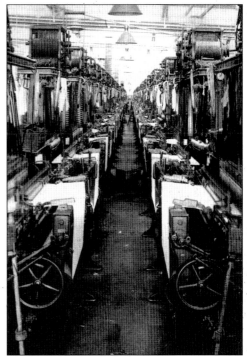

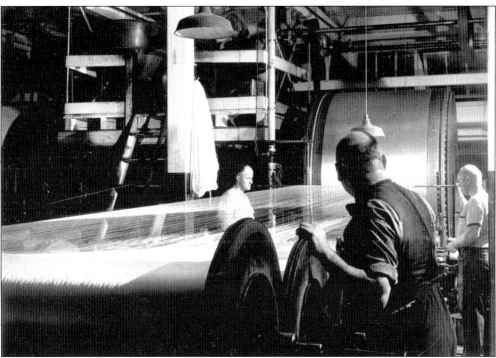

TENDING THE SLASHER AT PONEMAH MILL, NOVEMBER 1940. The slasher added sizing, a starchy solution, to the yarn used as warp in the looms. The extremely fine yarn spun by Ponemah had to be sized to enable it to be woven without breaking. The sizing would be washed out of the cloth later. (Photograph by Jack Delano, Work Projects Administration.)

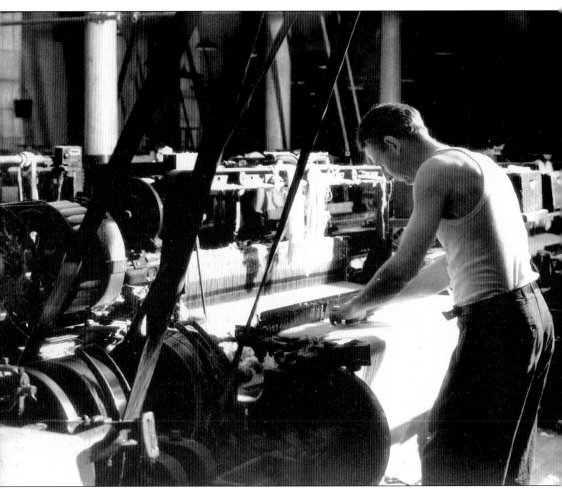

A Weaver at a Ponemah Mill Loom, November 1940. This photograph shows a weaver with the loom stopped, making a repair to the fabric. The heat and noise of the weave room called for informal clothing. To the weaver's left, belting from an overhead shaft drove the loom. The drum with bobbins in it is the battery. This supplied the shuttle with bobbins of yarn to carry across as filling between the warp yarns, creating cloth. (Photograph by Jack Delano, Work Projects Administration.)

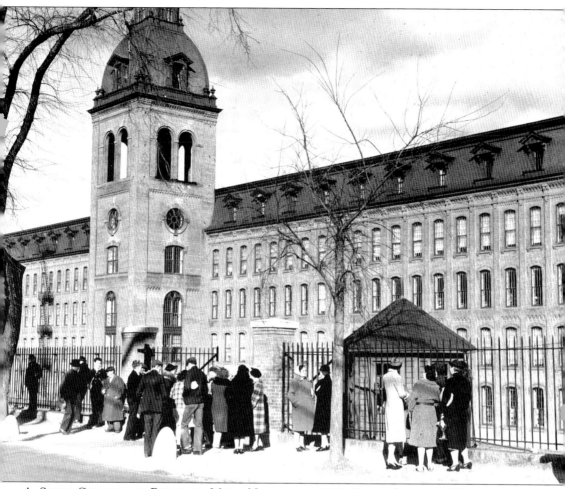

A Shift Change at Ponemah Mill, November 1940. Ponemah survived bitter labor strikes, the Great Depression, and the changing fortunes of the New England textile industry until 1972. It was one of the last of the great northern cotton mills to shut down. Its very name was said to mean "our future hope." Its survival for so long against the odds was due in part to innovative practices. Ponemah embraced new technology as it came available. Electric power was used to run machinery. An electric locomotive was used on a spur line to bring cotton bales from the main rail line. The mill used new synthetic yarns as well as traditional cotton yarns. (Photograph by Jack Delano, Work Projects Administration.)

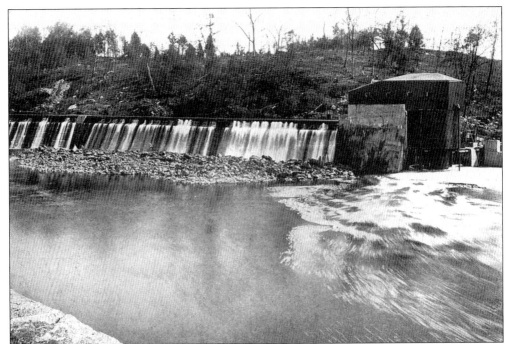

THE TUNNEL PLANT. This plant was built on the rapids of the Quinebaug River next to the Norwich & Worcester railroad tunnel. It used a subterranean chamber to entrap air and compress it. The compressed air was piped to Ponemah Mill and other industries. The effort was a technical failure. As it drove machinery, the compressed air expanded and cooled, causing mechanical problems. The plant was soon converted to hydroelectric use. (Courtesy the Otis Library.)

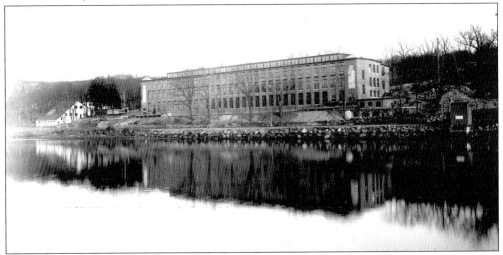

THE AMERICAN THERMOS BOTTLE COMPANY, C. 1913. Concerned that the local economy needed to expand and diversify its industrial base, Norwich lured Thermos to the city by offering to build this plant for its use. The Norwich Boomers raised $75,000 quickly. At either end of the building, giant Thermos bottles are set into the brickwork. As textiles and other industry declined, Thermos expanded, reaching a peak employment level of 1,200 workers by the mid-20th century. (Courtesy Faith Jennings.)

JOHN MEYER. Isaac Meyer moved the G & M Manufacturing Company to Norwich in 1937. G & M made men's clothing. John Meyer, Isaac's son, attended textile school and the University of Connecticut before entering the firm. Under his leadership, the company went into women's apparel, marketing to college and university students in particular. The name of the company was changed to John Meyer of Norwich in the early 1960s. It later became a division of W.R. Grace Company. Meyer was an active member of the Beth Jacob Synagogue and the United Jewish Appeal. (Courtesy the Otis Library.)

AN ADVERTISEMENT FOR JOHN MEYER. Meyer's wife, the former Arlene Hochman, had been a fine arts major at Connecticut College in New London. She was actively involved in the fashion end of the business. The stylish clothing appealed to young women nationwide. (Courtesy the Otis Library.)

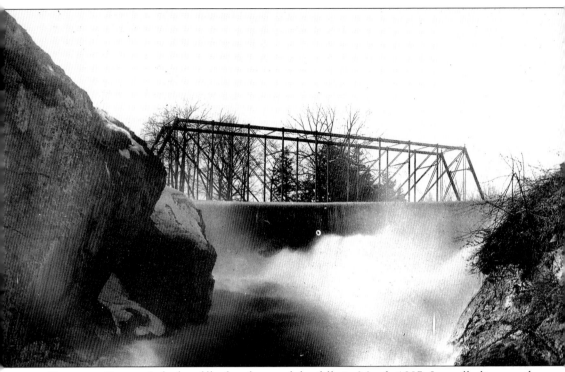

NORWICH FALLS. A freshet fills the chasm of the falls in March 1887. Ice still clings to the rocks on the shaded side of the gorge. "These are the well-known Norwich Falls, which at the time of a spring flood suddenly swell into sublimity, spanning the river with a sheet of foam, and filling the ravine with a heavy roar," said historian Frances M. Caulkins in 1866. The mill no longer diverts the flow of the Yantic River through its machinery. It has been converted into condominiums. Yet for those of us accustomed to the beat and rhythm of the carding machine, spinning frame, and loom, their silence is felt. The following words, written by Caulkins, are vested with new meaning: "In relation to manufactures, and in some respects it would apply to the whole business of the town, this was a period when old things passed away, and all things became new." (Courtesy the Otis Library.)

Three
TRANSPORTATION

As critical to Norwich's development as power, the transportation of goods and people was a necessary ingredient for success. Steam power on land and afloat, by railroad and steamboat, dominated the 1800s. Steamboat service between New York and Norwich began in 1817, when the steamboat *Connecticut* entered Norwich Harbor. Construction of a rail link to Worcester began in 1835. The line was completed in 1842. A survey of the proposed railroad route in 1833 revealed 100 mills along the line. Now, bales of cotton and other raw materials could be brought in by water and transferred to railroad cars. Bales of cloth and other finished product were shipped out in return. Industry flourished along the entire Norwich & Worcester line. Norwich prospered accordingly.

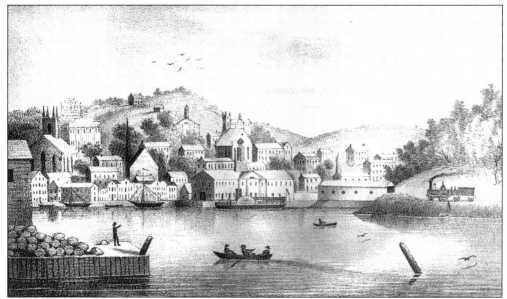

A VIEW OF NORWICH CITY FROM THE SOUTH, 1845. This view shows an early train coming from the Allyn's Point landing about to cross a covered railroad bridge. A steamboat is docked next to the freight depot, and two sloops are tied up at the waterfront.

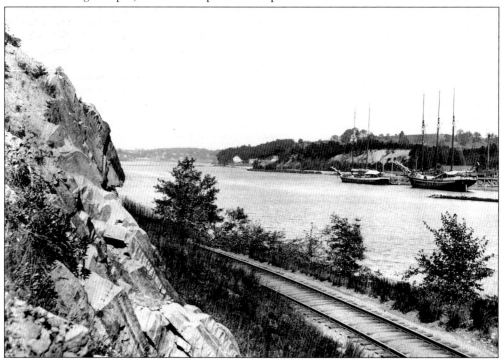

A BIT OF THE THAMES, 1898. Seen are a two-masted schooner and a three-masted schooner tied up at a wharf on the Thames River, south of the city. Schooners were the workhorses of the coastal trade. Their cargoes often included materials such as lumber, coal, or stone. The Thames River, a drowned estuary, was navigable up to Norwich. Spring floods, however, often moved sandbanks or changed the course of the shipping channel. (Courtesy the Otis Library.)

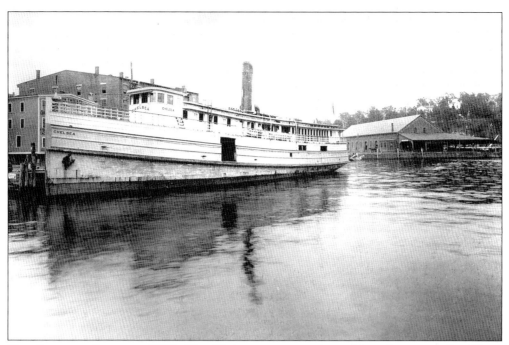

THE STEAMER CHELSEA, 1898. The *Chelsea* was a steamboat driven by a propeller. These smaller boats were more common than the larger, sumptuous paddle-wheel steamboats used for passengers. The *Chelsea* carried both freight and passengers and was described in 1895 as being "new and commodious." It plied Long Island Sound between pier 18 on the East River in New York and Norwich. (Courtesy the Otis Library.)

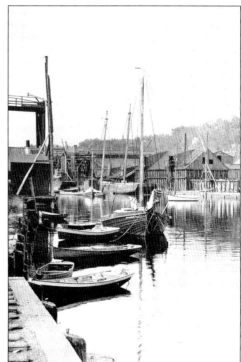

COAL POCKETS ON CENTRAL WHARF, 1898. A heavily laden schooner is tied up at Central Wharf next to a series of coal pockets, binlike buildings for holding coal. African Americans often worked at the coal pockets, as they were denied employment in most factories. The coal was intended for heating homes and businesses and for providing power to the mills. (Courtesy the Otis Library.)

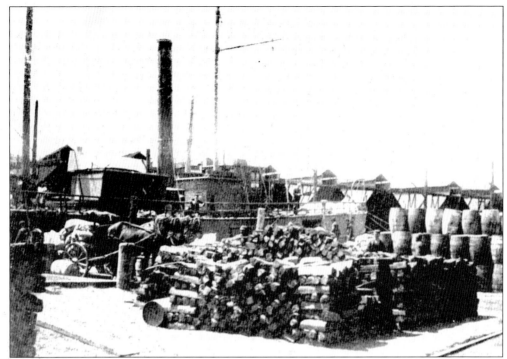

CARGO ON THE WHARF, 1880s. Barrels, stacked wood, and bales of cotton are piled on the wharf. A team of horses is hitched to a cart loaded with bales. The coal pockets are across the narrow channel. (Courtesy the Otis Library.)

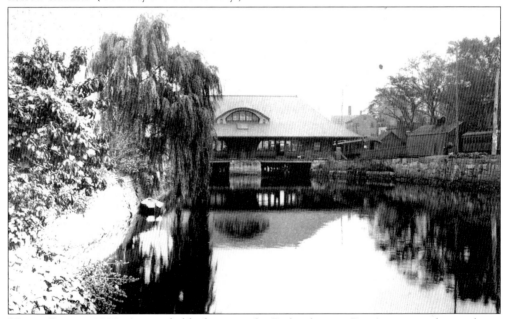

UNION DEPOT, 1898. A remarkable design in the Richardsonian Romanesque style popular in the 1880s and 1890s, Union Depot was built on pilings over the Yantic River channel at Central Wharf. The building was replaced in 1901 with one on a more substantial and safe foundation. (Courtesy the Otis Library.)

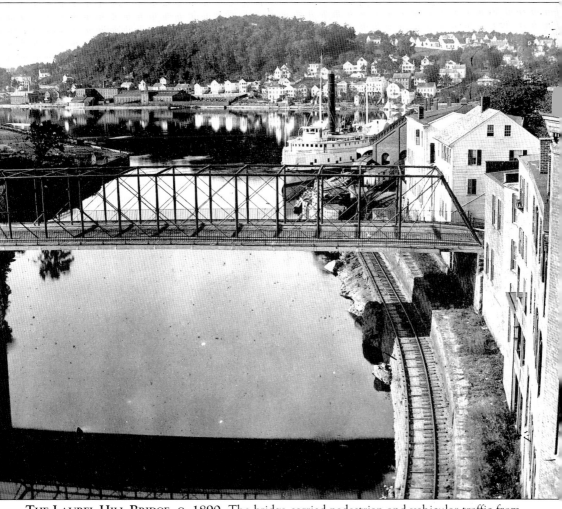

THE LAUREL HILL BRIDGE, C. 1890. The bridge carried pedestrian and vehicular traffic from Laurel Hill to the downtown. Beneath the bridge, the railroad bed hugs a narrow ledge next to the Shetucket River. Norwich Harbor, where the Shetucket ends, can be seen in the background. (Courtesy the Otis Library.)

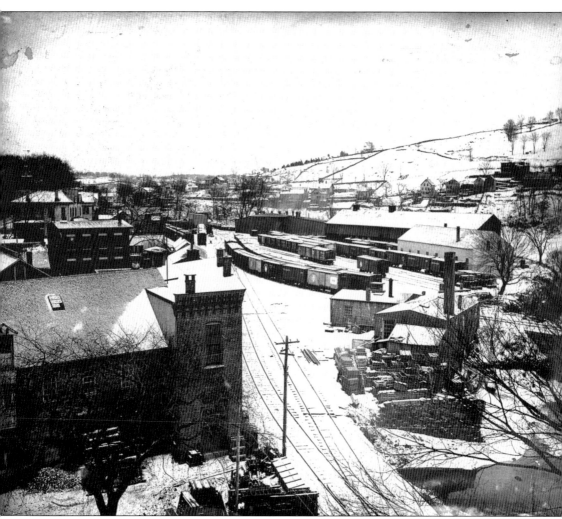

A FREIGHT YARD ON THE BANK OF THE SHETUCKET, THE 1880s. Behind Main Street downtown, this freight yard was used to marshal rail cars and to store goods in transit. On the opposite bank of the Shetucket, the hillside has open fields. This juxtaposition of city and country was common. Most people walked to work, living as nearby as possible. City centers were compact. (Courtesy Faith Jennings.)

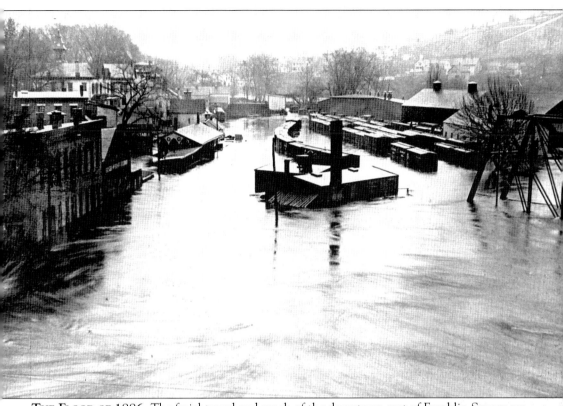

THE FLOOD OF 1886. The freight yard and much of the downtown east of Franklin Square are underwater. The railroad bridge was replaced in 1901 due to heavy damage in this and other floods. (Courtesy the Otis Library.)

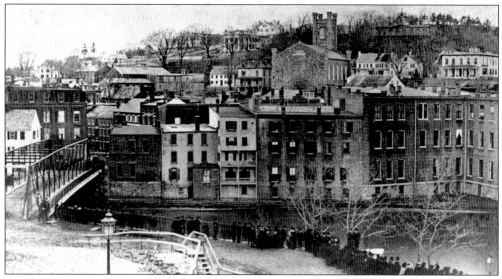

WATCHING THE FLOOD. A crowd gathers to watch the river rise over the railroad tracks below the Laurel Hill Bridge. (Courtesy the Otis Library.)

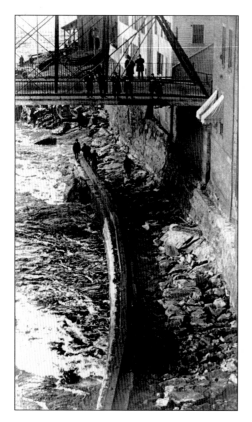

INSPECTING THE DAMAGE. Following the 1886 flood, men inspect the damage while others look on from the Laurel Hill Bridge. (Courtesy the Otis Library.)

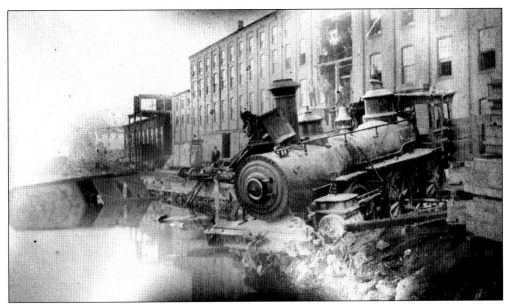

A Train Wreck, 1887. Not surprisingly, this engine has derailed not far from the Laurel Hill Bridge. The engine tips precariously over the river's edge, while a boxcar lies partially submerged nearby. (Courtesy the Otis Library.)

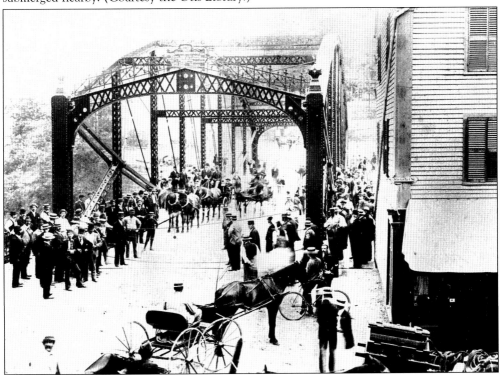

The Laurel Hill Bridge Opening, 1893. A new lenticular truss bridge, constructed by the Berlin Iron Bridge Company, was opened in 1893. Due to frequent floods and heavy usage, bridges at this location have had a short life spans. The new bridge was replaced 64 years later, in 1957. Today, the 1957 bridge is scheduled for replacement. (Courtesy the Otis Library.)

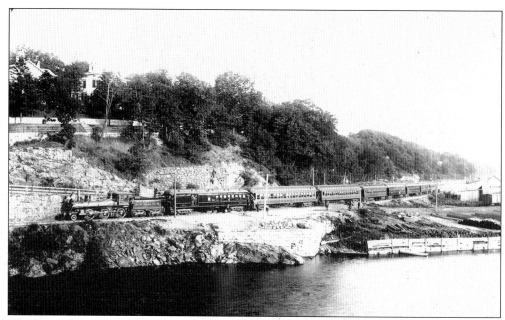

THE FIRST TRAIN FROM GROTON. An extension of the railroad to Groton, connecting with the shoreline route, opened in 1899. Here, the first train from Groton approaches Norwich. The mansions on Laurel Hill can be seen in the background. (Courtesy Faith Jennings.)

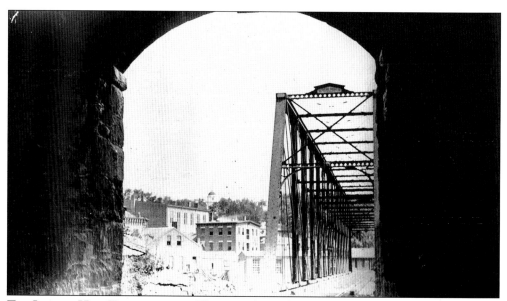

THE LAUREL HILL TUNNEL, 1887. This tunnel, cut through the rock at the base of the Laurel Hill Bridge, opened in 1876. The iron bridge carries the tracks across to the freight yard. The bridge was replaced in 1901. (Courtesy the Otis Library.)

THE RAILROAD TUNNEL ON THE QUINEBAUG RIVER, 1898. When the work gangs building the Norwich & Worcester line reached Bundy Hill near the junction of the Quinebaug and Shetucket Rivers, they were forced to tunnel through the base of the hill. The task proved a costly and time-consuming obstacle in the 1830s. The largely Irish crews worked with black powder and hand tools. (Courtesy the Otis Library.)

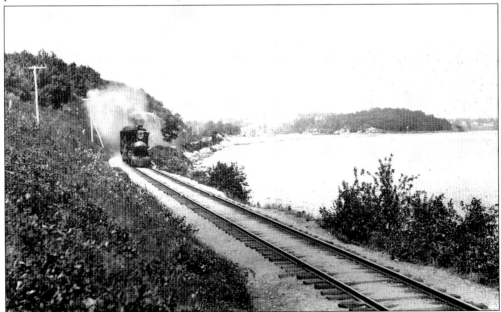

A TRAIN ON WEST BANK OF THE THAMES, 1898. The Norwich & Worcester line opened service to Worcester, Massachusetts, in 1842. The New London, Willimantic, and Palmer Railroad began construction in 1849. Its route ran along the west bank of the Thames River and up the Yantic River, crossing and recrossing the Yantic. (Courtesy the Otis Library.)

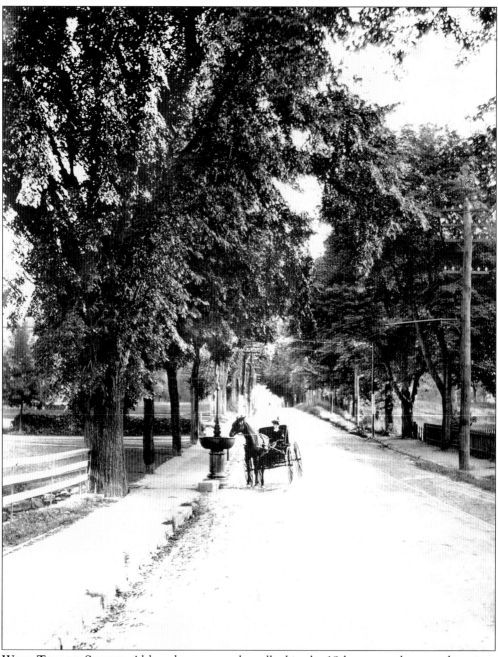

WEST THAMES STREET. Although most people walked in the 19th century, horse and carriage was a preferred mode of transportation for many, especially the more well-to-do. Water troughs were interspersed throughout the community. (Courtesy the Otis Library.)

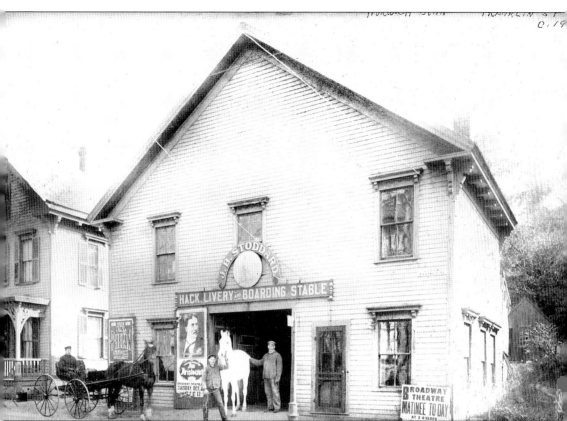

J.B. Stoddard's Hack, Livery, and Boarding Stable, c. 1900. The livery stable was indispensable for those who had horses in an urban area. Downtown Norwich was crowded with stables. This stable was located on Franklin Street, near the bustling Franklin Square. The Broadway Theatre was a short distance away, as the playbills on the stable attest. (Courtesy Faith Jennings.)

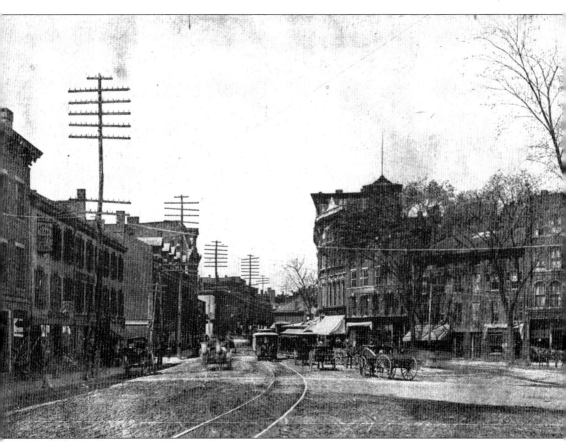

FRANKLIN SQUARE, 1888. Franklin Square was a main retail area in the downtown. It was also a hub of transportation. In the 1850s and 1860s, a horse-drawn omnibus was making two round trips daily between the downtown and Bean Hill, with stops along the way. In 1868, a street railway was started, with horse-drawn streetcars. Franklin Square was the starting point for the streetcars. The cars ran until 10:00 p.m. Merchants and others with business in the downtown could live in what were already being described as suburbs. (Courtesy the Otis Library.)

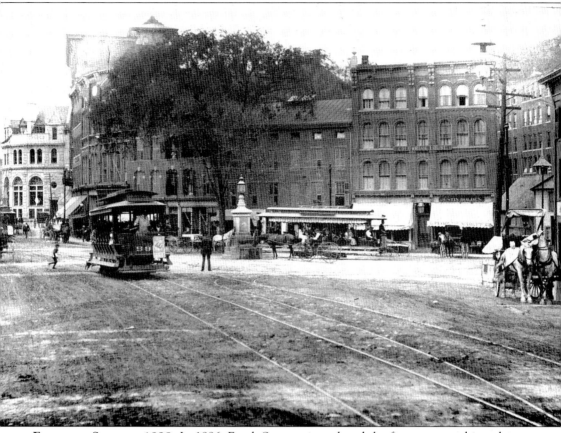

FRANKLIN SQUARE, 1898. In 1886, Frank Sprague introduced the first streetcar driven by an electric motor in Richmond, Virginia. The idea spread rapidly. Urban areas throughout America embraced the electric trolley as a safer, more sanitary alternative to horse-drawn streetcars. The Norwich City Council approved the use of electricity by the Norwich Street Railway Company in December 1891. Electrification of streetcars started in 1892. The *Evening Record* printed "The Song of the Horse," as follows:

> Hurrah for electricity that saves my tired feet,
> And wheels, with fleet lubricity, the cars along the street!
> What wonderful complicity of fate and human brain
> Have brought me this felicity of rest from toil and pain?

(Courtesy the Otis Library.)

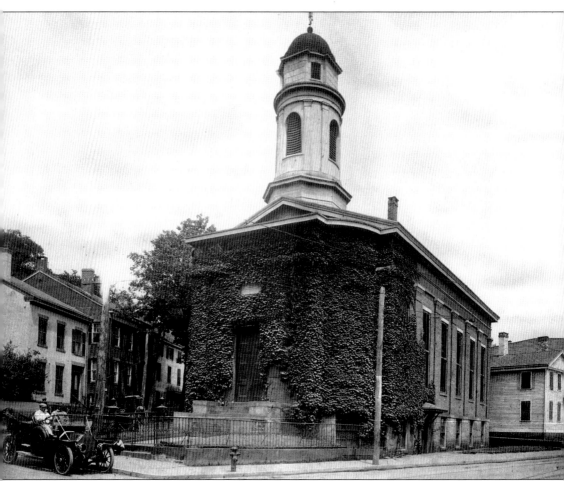

THE FIRST UNIVERSALIST CHURCH, 1910. Built in the 1840s, the Greek Revival church building visually anchored the east end of Franklin Square. This photograph was taken shortly before the demolition of the church for the construction of the new Chelsea Savings Bank. Fortunately, the neoclassical-style bank that replaced the church fulfills much the same role. The symbolism of the new motorcar in front of the church is unmistakable. Here is the spirit of progress made visible. Contrast the car with the buggy visible on the side street or the trolley tracks on Main Street, complete with horse manure. (Courtesy the Unitarian Universalist Church of Norwich.)

Four
A CITY OF VILLAGES

The original settlement of Norwich was two miles inland at Norwichtown. As the waterfront became a thriving seaport in the 1700s, a fierce rivalry developed. Chelsea, the seaport, became the city of Norwich in 1784. The city soon eclipsed the town in wealth and population. Government functions, trade, and commerce moved downtown. As manufacturing villages sprang up along the rivers, each with its own distinct identity, sectional rivalry increased. The dynamic tension continues today.

A VIEW OF NORWICHTOWN FROM THE EAST, 1845. Like most early settlements, the Congregational church dominated the green. The county courthouse, jail, taverns, and shops all clustered on the green in the 1700s and early 1800s. Set in the midst of meadows and fields, Norwichtown became a backwater, and the residents became concerned with maintaining its rural character. Ironically, many of them commuted into the city for work.

THE NORWICH TOWN GREEN, 1898. Early in the 1800s, residents planted trees around the green. In contrast to the downtown, the area became known as uptown, or round-the-square. Rival bands of boys from uptown and downtown would meet at a halfway point between the two for snowball fights. (Courtesy the Otis Library.)

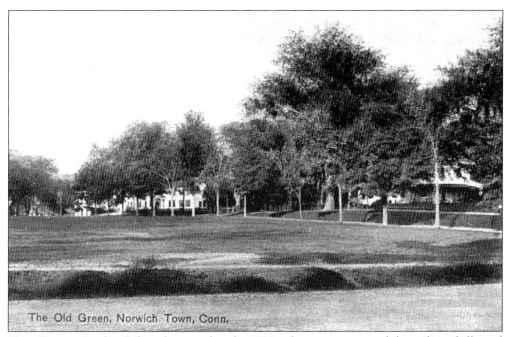

THE GREEN. In the Colonial era and early 1800s, the green was used for militia drills and public gatherings. By the end of the century, it was primarily used for recreation. (Courtesy the Otis Library.)

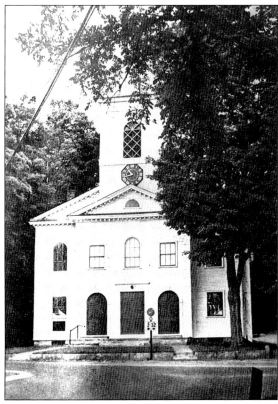

THE MEETINGHOUSE OF THE FIRST CONGREGATIONAL CHURCH. The meetinghouse on the green was a powerful symbol of the primacy of Protestant values. Faced with rapid change, the influx of immigrants, and new denominations, the old stock Yankees looked back with nostalgia to an earlier era. Two ministers of the church had served for more than 50 years. The present building was built in 1801. An arsonist destroyed the previous structure. (Courtesy the Otis Library.)

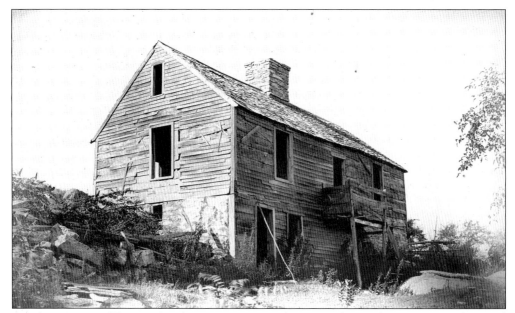

AN ABANDONED HOUSE. Another improvement the Norwich Rural Association advocated was the removal of old dilapidated houses. Members of the association believed that "an old house is not on account of its antiquity alone worthy of more respect than an old hat." Fortunately, they noted in a 1907 report, there had been many instances of "justifiable domicide" in Norwich. (Courtesy the Otis Library.)

THE 1762 COURTHOUSE. After the courts moved downtown in 1829, the old courthouse on the green was used as a school. It was demolished in 1891. (Courtesy the Otis Library.)

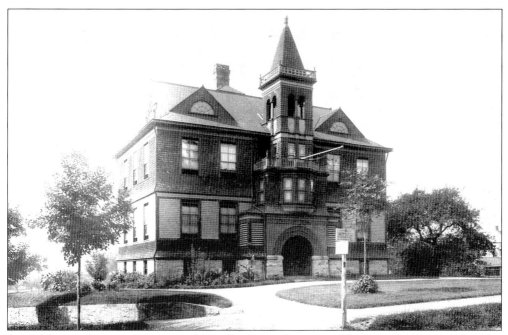

JOHN MASON SCHOOL. The site of the school was the original home lot of Norwich founder Maj. John Mason. After demolition of the old courthouse, the new building, in the popular Queen Anne style, was named after Mason. (Courtesy the Otis Library.)

THE YANTIC RIVER, NORWICH TOWN, 1898. The New London Turnpike crosses the Yantic here. Once the main road between Norwich and New London, by the mid-1800s, its importance had diminished. Railroad and steamboat travel was easier. (Courtesy the Otis Library.)

BEAN HILL. At the northwest end of the original settlement, Bean Hill maintained a distinctive identity. A small green, visible in this photograph, attracted stump speakers. Shops on the hill served outlying farmers in Norwich and neighboring towns. Residents of Bean Hill had a reputation for being eccentric. The church is a Methodist church built in 1831. (Courtesy Faith Jennings.)

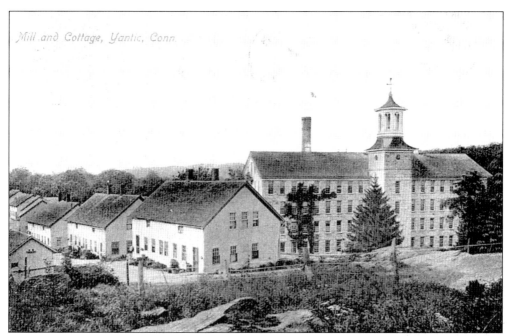

THE YANTIC MILL AND COTTAGES. The Yantic Mill was a woolen mill owned by Capt. Erastus Williams and later by his son E. Winslow Williams and grandson Winslow Tracy Williams. The mill burned in 1865. Construction of the present stone mill was started three months after the fire. Woolen mills were generally smaller in scale than cotton mills. (Courtesy the Otis Library.)

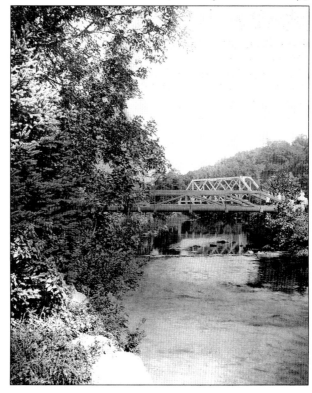

A VIEW ON YANTIC RIVER AT YANTIC, 1898. The bridge in the foreground is a bridge for access to the mill from housing on the other side of the river. In the background is the railroad bridge. (Courtesy the Otis Library.)

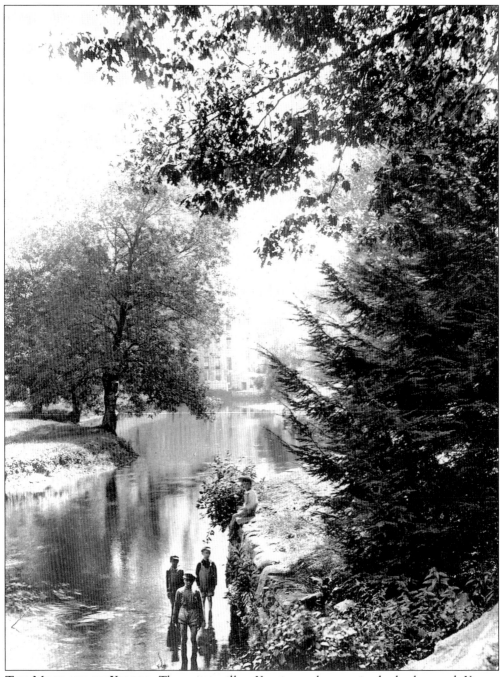

THE MILLRACE AT YANTIC. The stone mill at Yantic can be seen in the background. Young children such as these found millraces hard to resist. Child labor regulations had just gone into effect when this photograph was taken in the 1890s. (Courtesy the Otis Library.)

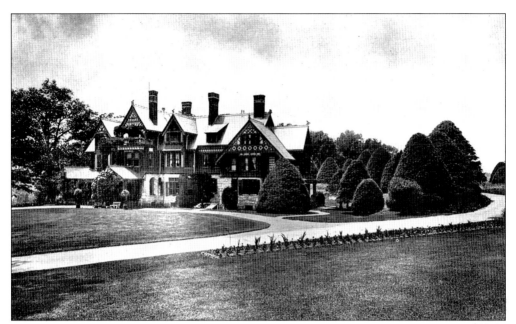

ROCKCLYFFE, 1909. The elaborate mansion of Winslow Tracy Williams was near the Yantic Mill. The style was a variation of the Queen Anne style. (Courtesy the Otis Library.)

THE YANTIC BRIDGE. Winslow Tracy Williams, chairman of the Norwich 250th anniversary celebration in 1909, invited Pres. William Howard Taft to Rockclyffe. Williams had a new stone bridge constructed for the occasion to replace the older bridge. In this photograph, the presidential party is returning to Norwich from Rockclyffe. (Courtesy the Yantic Fire Engine Company.)

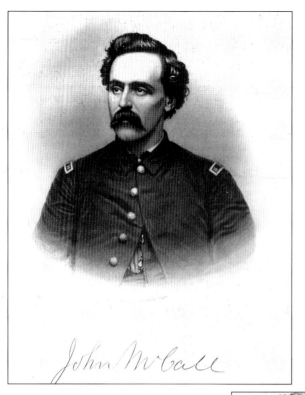

CAPT. JOHN MCCALL. In 1866, historian Frances M. Caulkins said, "The Village of Yantic furnished an honorable roll of volunteers in the war for the Union; and among them, one—Capt. John McCall,— who poured out his life on the banks of the James River, and by his patriotism, valor, and heroic death, has left a name for his native hills to cherish." (Courtesy the Otis Library.)

THE GRAVESTONE OF CAPTAIN MCCALL. The symbolism here is obvious: a young man whose life is cut short by death. (Photograph by the author.)

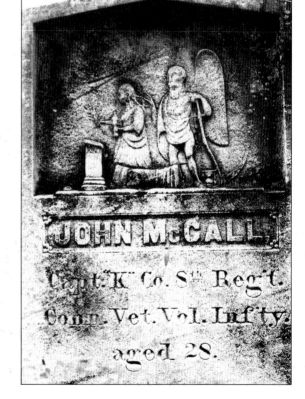

ST. MARY'S CHURCH, GREENEVILLE. Irish laborers worked on the Greeneville dam and power canal in 1828. In 1835, they worked on the Norwich & Worcester Railroad. A shantytown, Toomeytown, grew up on the banks of the Shetucket. By 1842, the number of Irish families justified the construction of St. Mary's, the first Roman Catholic church in Eastern Connecticut. With the potato famine of the 1840s, more Irish joined those already in Greeneville. By the late 19th century and early 20th century, Poles and other eastern Europeans began to move into Greeneville. (Courtesy the Otis Library.)

CENTRAL AVENUE, GREENEVILLE. By the post–Civil War era, the Irish had prospered in Greeneville. Patrick Kelly built the imposing Romanesque Revival block on the left in 1896. The storefronts are of cast iron. Upper floors were rental apartments. Greeneville, only a mile from the downtown and connected by streetcars even in the horse-drawn era, was absorbed by the city in the 1870s. (Courtesy the Otis Library.)

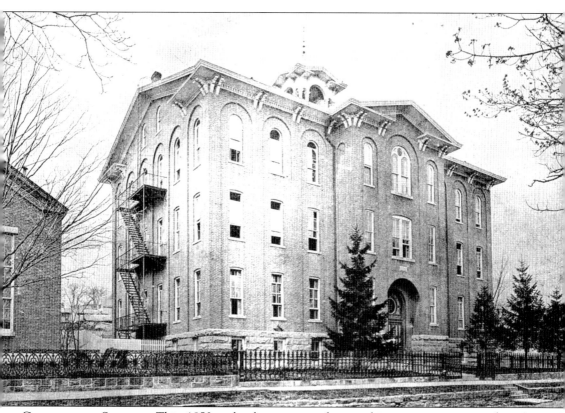

GREENEVILLE SCHOOL. This 1850s school was part of an ambitious program to replace older, smaller schools with larger ones that could offer more to the students. In 1956, the present Greeneville School was built. This building was torn down for a play area. (Courtesy the Otis Library.)

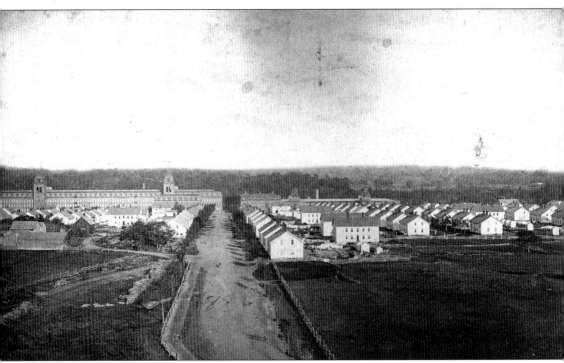

TAFTVILLE AND PONEMAH MILL, C. 1884. Ponemah Mill dominates the village of Taftville. A strike in 1875 had led to the dismissal of most of the workers, many of them Irish, and their replacement with French Canadians. Isolated from the rest of the city with a relatively homogeneous population, Taftville was virtually self-sufficient. The mill had a company store with fresh produce and milk from the company-owned farm. When the mill electrified at the end of the century, it supplied electricity to the entire village. (Courtesy Rene L. Dugas Sr.)

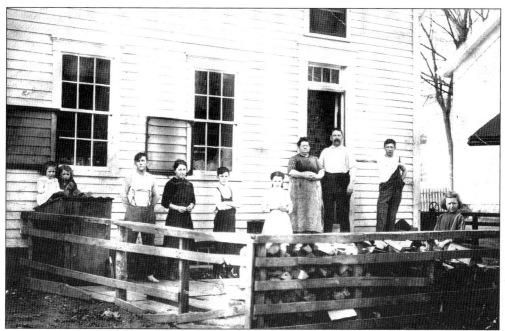

THE DUGAS FAMILY. The parents, Hosanna and Prime Dugas, stand by the doorway. From left to right, their children are Eva, Rene, Edmond, "Sina," Adolphe, Marianna, Joseph, and Bernadette. The Dugas family came to Taftville from Canada to find employment and escape poverty. Prime Dugas was the photographer of Taftville. His son, Rene Dugas, followed him in the trade. (Courtesy Rene L. Dugas Sr.)

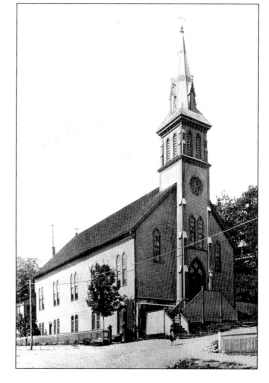

THE SACRED HEART CHURCH. Built in 1876, this attractive Gothic Revival church served the predominantly French Canadian work force. After construction of the new Sacred Heart Church, the building was used by the Sacred Heart Young Men's Association (SHYMA) and the Sacred Heart Young Ladies' Association (SHYLA). (Courtesy the Otis Library.)

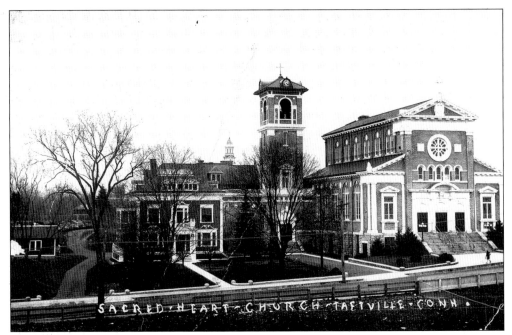

THE SECOND SACRED HEART CHURCH. The second Sacred Heart Church was completed in 1916. It was destroyed by an arson fire in 1956. (Courtesy Rene L. Dugas Sr.)

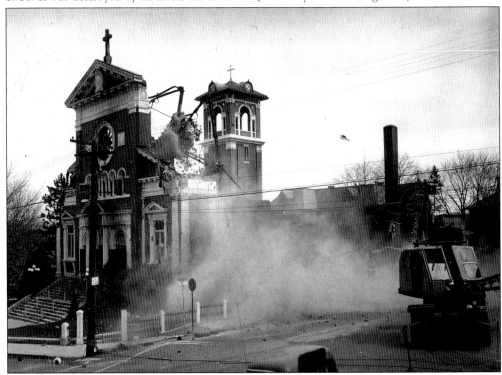

THE RAZING OF THE SECOND SACRED HEART CHURCH. A third church now stands on the site. The fact that virtually the entire community of Taftville worshiped together contributed to the solidarity of the village. (Courtesy Rene L. Dugas Sr.)

WILLIAM BREAULT. Taftville, like so many other villages, sent men to war. William Breault, whose family lived at 22 South A Street in Taftville, was one of those who did not return from World War I. The village has its own war memorial. (Courtesy Rene L. Dugas Sr.)

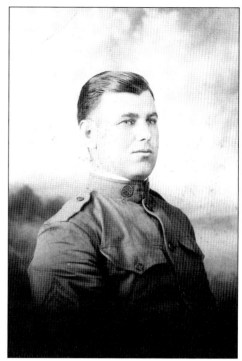

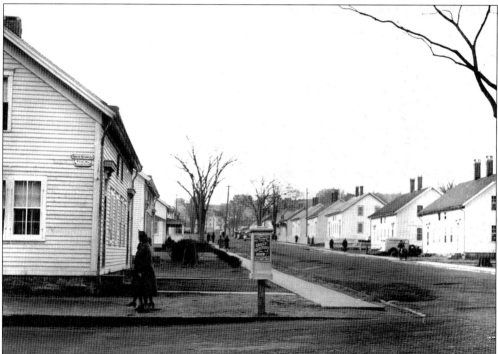

TAFTVILLE, 1940. This scene shows the worker housing. Originally, the mill owners had owned the entire village and rented to their employees. Eventually, the company sold the houses to the workers. The ghost basketball that is advertised was played with white shirts under ultraviolet light. (Photograph by Jack Delano, Work Projects Administration.)

RENE L. DUGAS SR., 1946. A lifelong resident of Taftville, Rene L. Dugas Sr. has chronicled the history of the community in his own photographs and those of his father, Prime Dugas. He also headed the Wequonnoc movement, which sought to create a new town out of the villages of Taftville and Occum in the 1940s, "because the people of this district have an inborn feeling or yearning to be free." (Courtesy Rene L. Dugas Sr.)

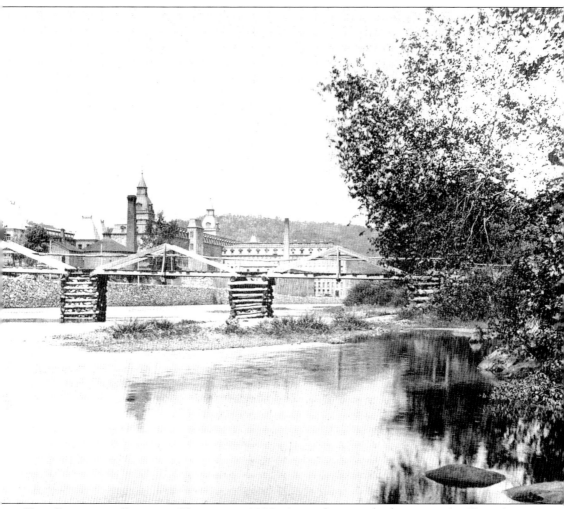

THE SHETUCKET RIVER AT TAFTVILLE, 1898. A wooden truss bridge across the Shetucket River is supported on timber cribs filled with stone. In 1728, a bridge being built near this site collapsed, killing two people and seriously injuring twenty more. The photograph shows clearly the 200-foot-long ell at the rear of Mill No. 1. The ell contained the turbine that powered the entire mill building. (Courtesy the Otis Library.)

BROADWAY AT CHELSEA PARADE. Chelsea Parade was given to the city in 1797. Halfway between Norwichtown and downtown Norwich, it was not developed until the middle of the 19th century. Prosperous merchants, bankers, lawyers, and others moved into the newly fashionable area. The Italian villa–style mansion on the right side of the street was owned by Gen. William G. Ely in the years following the Civil War. (Courtesy the Otis Library.)

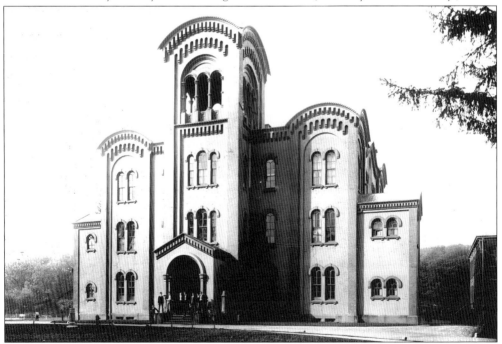

NORWICH FREE ACADEMY. In 1853, Rev. John P. Gulliver, of the Broadway Congregational Church, started a drive to raise funds for a free secondary school in Norwich. Students would be prepared to go on to college or enter a profession. The academy was to be free to residents of Norwich. He raised $100,000, a staggering sum at the time. Local architect Evan T. Burdick designed the building. The academy was incorporated in 1854. (Courtesy Faith Jennings.)

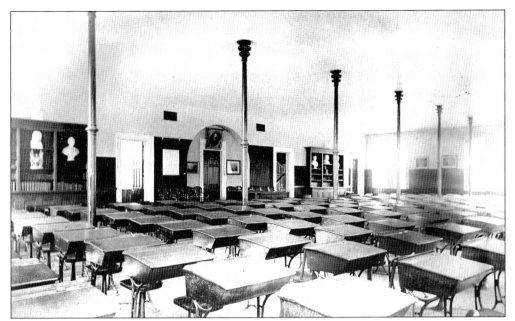

A NORWICH FREE ACADEMY CLASSROOM, SEPTEMBER, 1888. "In the course of instruction it forms a link between the college and the common school. But as it receives scholars of either sex from all classes and conditions in life, it is expected to be not only a classical and scientific school, but also to give attention to practical principles and polite literature," said historian Frances M. Caulkins in 1866. (Courtesy the Otis Library.)

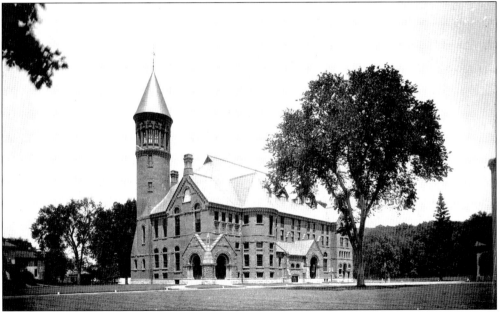

SLATER MEMORIAL. William Augustus Slater gave this building to Norwich Free Academy in 1886 as a memorial to his father. Designed by Worcester architect Stephen C. Earle in the Romanesque Revival style, the building contains a lecture hall, library, classrooms, and exhibition space. Shortly after its dedication, plaster copies of classical statues were obtained from Europe. (Courtesy Faith Jennings.)

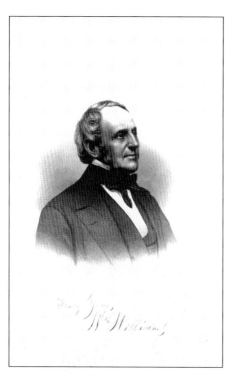

GEN. WILLIAM WILLIAMS. A native of Stonington, Connecticut, William Williams moved to Norwich in 1809. In partnership with lawyer Calvin Goddard and members of his own family, he manufactured flour from wheat and corn shipped in company-owned vessels from Virginia. When the War of 1812 interrupted this business, the partners turned their efforts towards cotton manufacturing. In 1829, Williams became the partner of Acors Barns in the whaling firm of Williams & Barns, operating out of New London. Active in missionary work both abroad and at home, Williams supported the Congregational church built on the Mohegan reservation. For many years, he volunteered as a school visitor, kneeling on the floor of small rural schools, leading children in prayer. (Courtesy the Otis Library.)

HARRIET PECK WILLIAMS. The daughter of Capt. Bela Peck, Harriet Peck married William Williams in 1812. Noted for her philanthropy and quick wit, she helped establish the Peck Library at Norwich Free Academy in 1859. The Williamses gave land to the Norwich Free Academy and donated the site for the Park Congregational Church. Harriet Williams, then widowed, donated the clock for the church. On hearing the remark that the clock was like its donor because it was full of good works, the elderly lady replied that, like her, it bore the marks of time on its face. (Courtesy the Otis Library.)

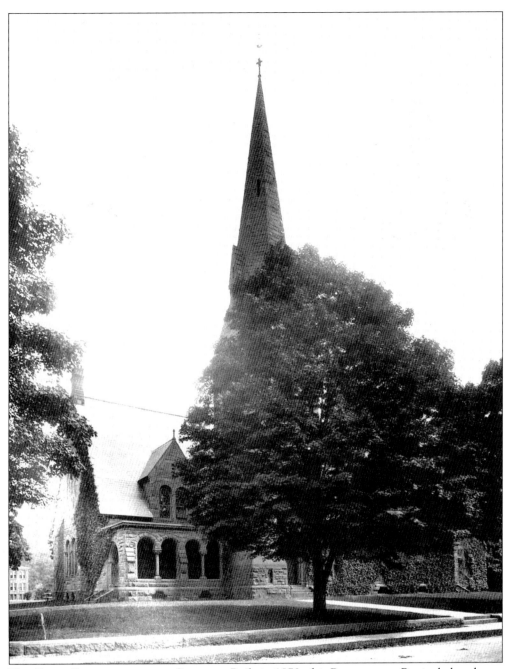

THE PARK CONGREGATIONAL CHURCH. Built in 1873, this Romanesque Revival church was designed by architect Stephen C. Earle of Worcester, Massachusetts. The church was founded by members of the Broadway Congregational Church. The area around Chelsea Parade was becoming a fashionable residential district, and its residents sought a church nearer than those downtown or in Norwichtown. (Courtesy the Otis Library.)

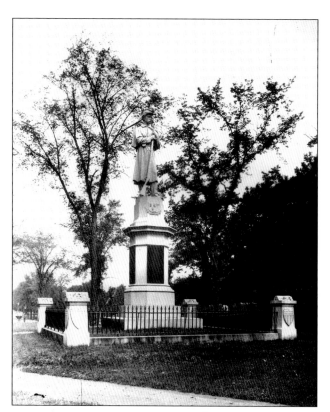

THE SOLDIERS MONUMENT. Carved of Westerly granite, this is one of the first memorials to those who fell in the Civil War. Dedicated in 1873, it is located at the northern end of the Chelsea Parade. The names of all those from Norwich who died in the war are engraved on a bronze plaque. (Courtesy Faith Jennings.)

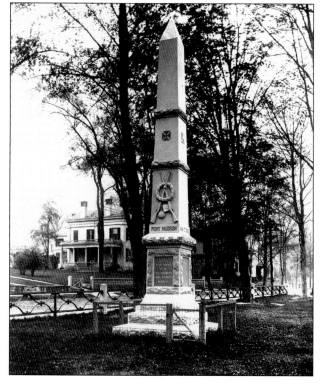

THE 26TH CONNECTICUT VOLUNTEERS MONUMENT. Members of the 26th were men who volunteered to serve for nine months. They fought in only one major engagement, the siege of Port Hudson, Louisiana. (Courtesy Faith Jennings.)

Five
NORWICH AT PLAY

During the 19th century, there was an increasing amount of leisure time available for many. For many of the wealthy, income from investments freed them from day-to-day toil. Labor regulations restricting the hours in a workday and transportation improvements made a difference also. Increasingly, men and women of Norwich found amusement in sport, theater, and other forms of entertainment and recreation.

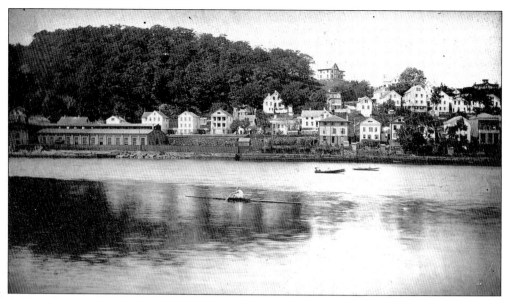

A MAN ROWING, C. 1900. A man in a shell rows downstream on the Thames River. Rowing was a popular 19th-century activity, whether alone or in company. Other small rowing vessels can be seen, but not distinctly. The West Side and the Richmond Stove Company can be seen in the background. (Courtesy Faith Jennings.)

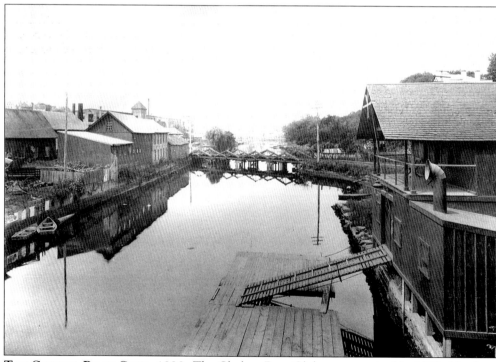

THE CHELSEA BOAT CLUB, 1898. The Chelsea Boat Club was organized in 1877. Members constructed a boathouse on the channel of the Yantic River near Central Wharf. Small craft were kept here for use by the members. While simple in construction, the boathouse has a truss in the gable peak. (Courtesy the Otis Library.)

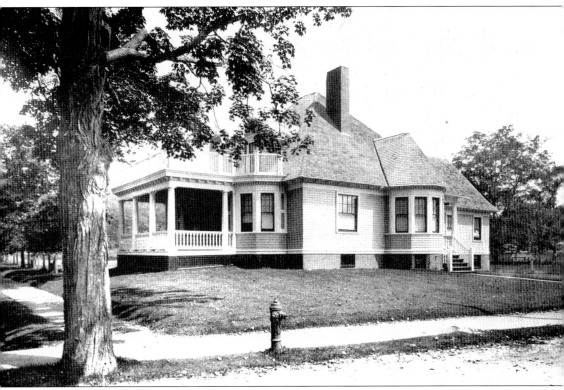

THE NORWICH CLUB. The Norwich Club was organized c. 1896. Located on the corner of Crescent Street and Joseph Perkins Road, the club provided facilities for tennis and croquet. It is now a private residence. (Courtesy the Otis Library.)

A FOOTBALL TEAM IN FRONT OF NORWICH FREE ACADEMY, OCTOBER 1886. Football was a popular sport with young men. Norwich Free Academy and Bulkeley School in New London had a friendly rivalry that lasts to this day. This photograph was taken in front of the academy building. (Courtesy the Otis Library.)

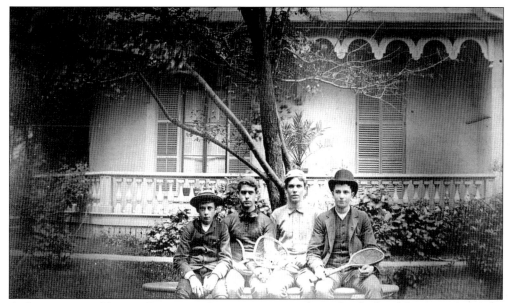

A GROUP WITH TENNIS RACKETS, OCTOBER 1885. The individual on the far right of the photograph is probably Albert Sprague Bard, son of Charles Bard, the owner of the house. (Courtesy the Otis Library.)

YOUNG WOMEN WITH LAWN TENNIS RACKETS, JULY 1886. While the location is not known, this photograph may have been taken in the Chelsea Parade area. (Courtesy the Otis Library.)

A Photograph Album, c. 1901.
Ollie Davison, a young clerk, sent this album to relatives at Christmas. Women of the time were increasingly employed in offices, loosening traditional roles.

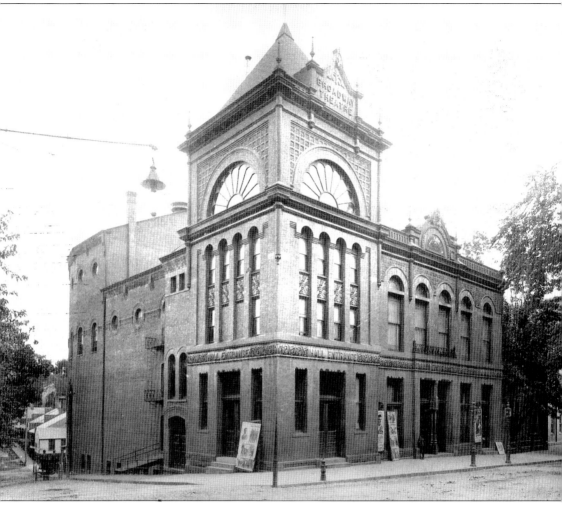

THE BROADWAY THEATRE, 1898. The Broadway Theatre was built in 1890 in the Richardsonian Romanesque style. It featured shows brought in from New York, vaudeville acts, and famous performers such as Sarah Bernhardt, Jenny Lind, and Arthur Conan Doyle. The wealthy William A. Slater, son of cotton mill giant John Fox Slater, was on the board and subsidized some of the costs. (Courtesy the Otis Library.)

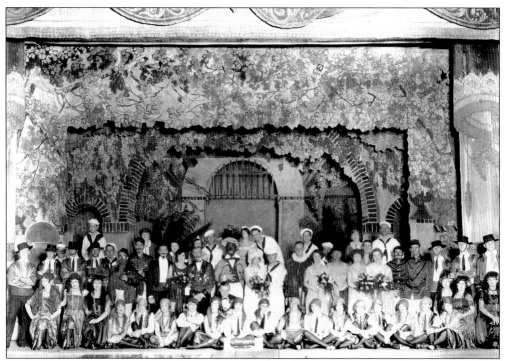

PRINCESS BONNIE AND BIMBO. These two plays were produced in 1925 by the Legion. The location is probably the new Masonic temple on the corner of Washington and Sachem Streets. Norwich has a long tradition of amateur theater production by local civic groups. Church groups were particularly active. (Courtesy the Otis Library.)

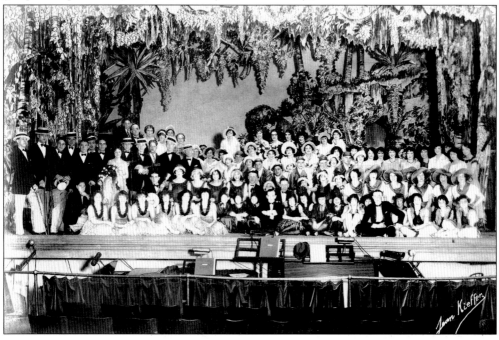

NORWICH SUMMER THEATRE, 1950. The summer stock theater brought in nationally known stars such as Eddie Albert. Stars often stayed at the Wauregan Hotel, downtown. Gypsy Rose Lee, the famous ecdysiast, made several appearances. Locals would usher and play bit roles if needed. (Courtesy the Otis Library.)

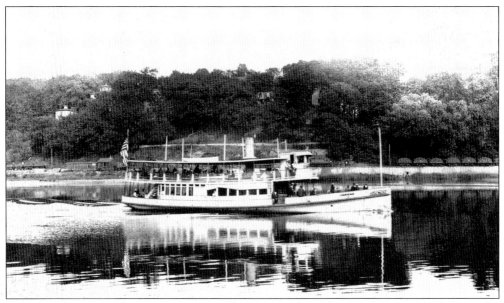

THE GYPSY, 1898. The Gypsy was a small excursion boat that made two trips daily in the summer to New London and back. Stops were made in Montville, Gales Ferry, New London, and Eastern Point in Groton. The fare varied according to the destination, but was 25¢ or 30¢ one way and 40¢ or 50¢ round trip. During the afternoon trip, passengers had an hour to bathe in the salt water. (Courtesy the Otis Library.)

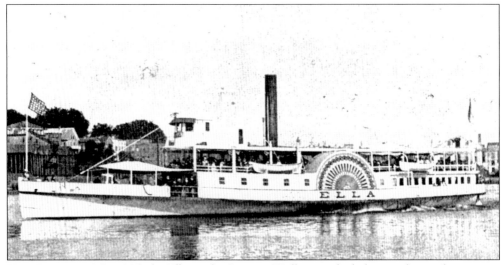

THE ELLA, 1895. In 1895, the Ella, under Captain Walker, made daily trips during the summer to Watch Hill, stopping at points along the way. In 1874, respected Congregational clergyman Leonard W. Bacon had complained that prostitutes were actively practicing their trade on the Ella. (Courtesy the Otis Library.)

THE ENTRANCE TO SACHEM PARK, 1898. The trolley line or street railway opened Sachem Park only to close it by 1900, five years later. To encourage riders, companies often opened attractions along the line, including amusement parks or waterside parks such as Sachem Park. The trolley track runs directly past the entrance. (Courtesy the Otis Library.)

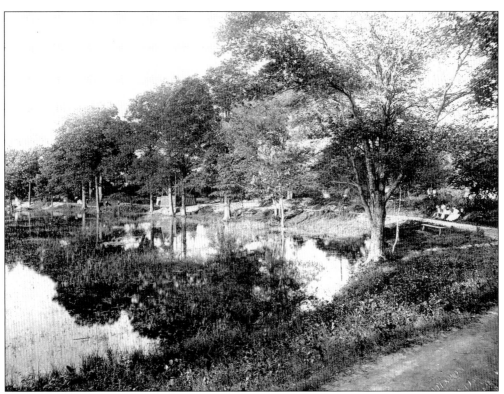

SACHEM PARK. The park was at the end of Boswell Avenue near the city line. The water is apparently the impoundment behind the Greeneville dam. (Courtesy the Otis Library.)

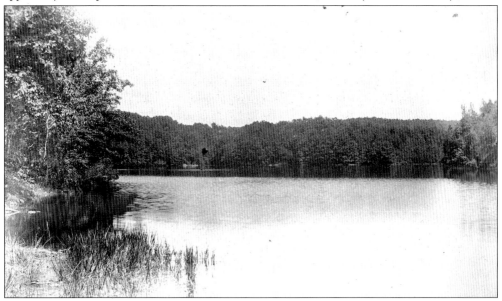

SPAULDING POND, C. 1887. The pond is man-made, one of several designed to bring waterpower to small mills farther downstream. Dr. John A. Rockwell donated 70 acres of land around the pond to the city in 1907. This became the nucleus of Mohegan Park. (Courtesy the Otis Library.)

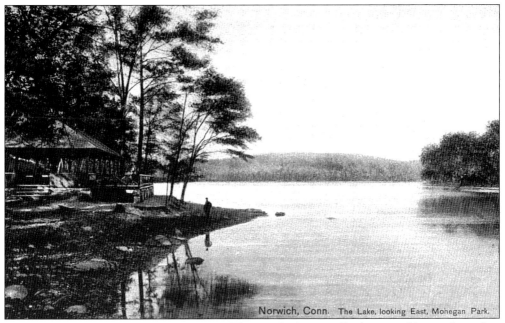

THE LAKE AT MOHEGAN PARK, C. 1908. The pond is essentially the same 21 years later, but with a pavilion and some landscaping. It was named Mohegan Park in honor of the local tribe in 1908. (Courtesy the Otis Library.)

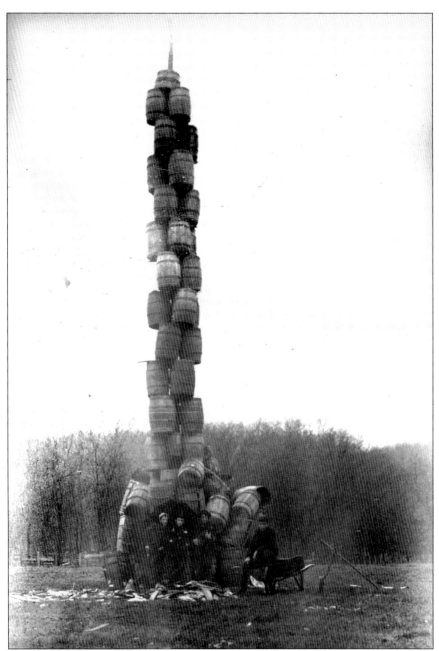

BARREL BURNING, THANKSGIVING 1886. In 1866, historian Frances M. Caulkins reported that "A peculiar adjunct of this festival [Thanksgiving] in Norwich was a *barrel bonfire*. A lofty pole was erected, around which a pyramid of old barrels was arranged,—large at the platform, but a single barrel well tarred forming the apex. The burning of this pile constituted the revelry or triumphant part of this entertainment, and was considered by the young as indispensable to a finished Thanksgiving." Rival gangs of boys roamed the town looking for barrels to appropriate. The tradition continued until World War II. The replacement of barrels with cardboard containers was a factor in the end of this custom, as well as wartime blackouts. (Courtesy the Otis Library.)

Six
BUSINESS AND HOME

The city was an important retail market for its own residents. Shoppers from outlying towns also purchased goods in Norwich. Some wholesale grocers sold produce and foodstuffs to the steamboats that put in to port. Others provisioned grocers inland. As the population grew and transportation within the city improved, so did sales.

Passengers coming into town and people with business in Norwich also needed hotel rooms, restaurants, and other services. As the population and wealth of the community itself burgeoned, local stores benefited. New residences and neighborhoods flourished in the city proper, many just outside the crowded central business district. New churches were built, and old ones were remodeled to meet the needs of the residents.

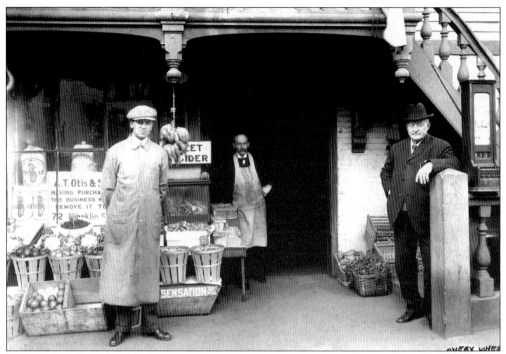

THE WHEELER BROTHERS STORE. On Cliff Street in the downtown, the Wheeler brothers are being forced to relocate. Albert Wheeler is inside the doorway and Avery Wheeler is to the right. Small grocers like the Wheelers were a common sight in most urban centers. (Courtesy Faith Jennings.)

GROCER'S ADVERTISEMENTS, 1888. Most of these grocers did either wholesale or retail trade. Their stores were often near the waterfront for easier access to the wharves. (Courtesy the Otis Library.)

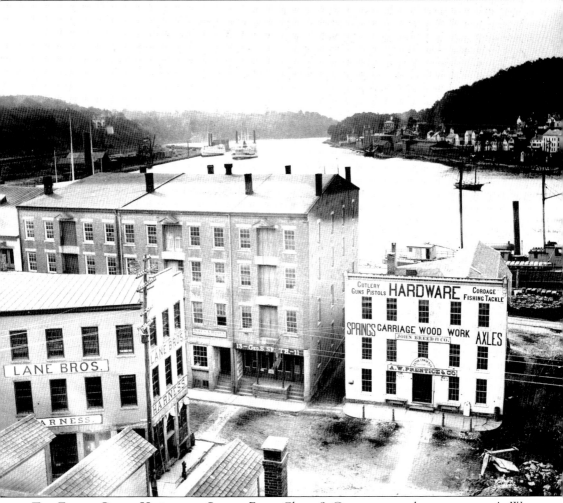

THE EATON CHASE HARDWARE STORE. Eaton Chase & Company was the successor to A. W. Prentice & Company, whose sign is still given more prominence than Eaton Chase's was. Other stores and warehouses are crammed into the area by the wharf. Cargo is on both the wharf and the deck of the steamer. (Courtesy the Otis Library.)

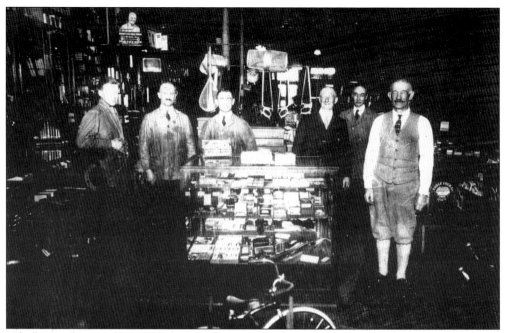

THE INTERIOR OF EATON CHASE & COMPANY. In this view, Albert H. Chase is to the right. (Courtesy Faith Jennings.)

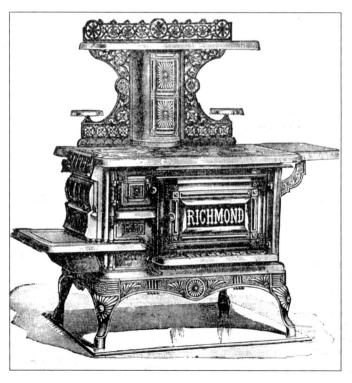

A JOHN P. BARSTOW & COMPANY ADVERTISEMENT. John P. Barstow & Company sold Richmond stoves, which were made in Norwich at a foundry on the West Side. (Courtesy the Otis Library.)

ALFRED H. VAUGHAN & SONS, IRON FOUNDERS. Alfred H. Vaughan & Sons cast a wide variety of metal goods. Many downtown storefronts, including that of the Vaughan office, were made of elements cast by the company. (Courtesy the Otis Library.)

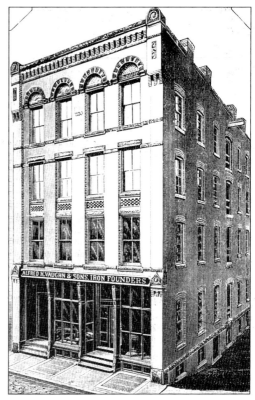

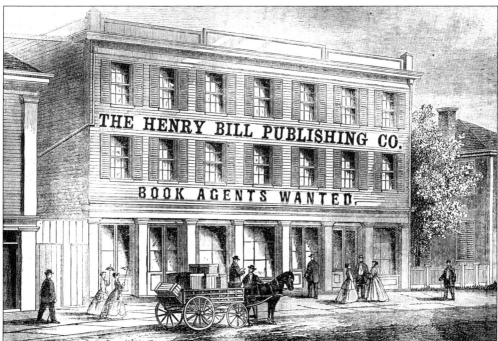

THE HENRY BILL PUBLISHING COMPANY, C. 1870. With offices on Shetucket Street across from Banker's Row, Henry Bill published illustrated Biblical histories sold by traveling salesmen. the company also published books about America in German, which sold readily abroad.

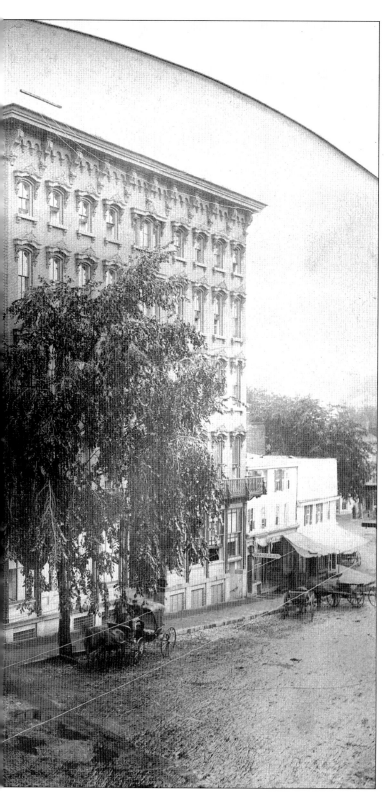

THE WAUREGAN HOTEL, C. 1870. Completed in 1855, the Wauregan was the centerpiece of the downtown for a century. Designed to be the best hotel between New York and Boston, it featured extremely modern appointments. When first built, central heating was used and light was furnished by gas. The structure itself was a composite of masonry and cast iron. The planning meetings for the bicentennial celebration, and many other business and social gatherings, were held here. (Courtesy Richard Sharpe.)

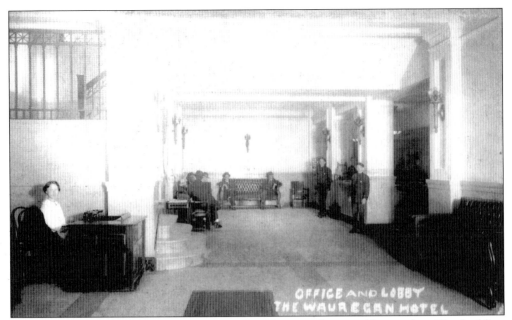

THE WAUREGAN HOTEL LOBBY, C. 1906. The Wauregan kept itself up-to-date. The building was remodeled at the time of this photograph, and a marble lobby was installed. The public could use the services of a public typewriter and stenographer posted within the lobby. (Courtesy the Otis Library.)

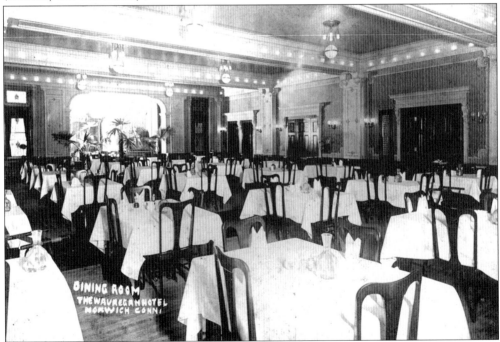

THE WAUREGAN HOTEL DINING ROOM. A six-story extension to the Wauregan, the Clarendon annex, contained a dining room on the second floor. A stage allowed theatrical performances. The room could also double as a ballroom. In the 20th century, the room hosted many social functions in town. (Courtesy the Otis Library.)

JAMES B. SHANNON. Born to Irish parents in New York in 1845, Shannon came to Norwich in 1867. He manufactured and sold liquor and cigars on Water Street. As the Prohibition movement made gains, Shannon went into real estate in 1878. By the time of his death in 1917, he had built or remodeled more than 20 buildings, most of which were downtown. A member of the Democratic party, Shannon owned a woolen mill in Baltic as well as other textile investments. (Courtesy the Otis Library.)

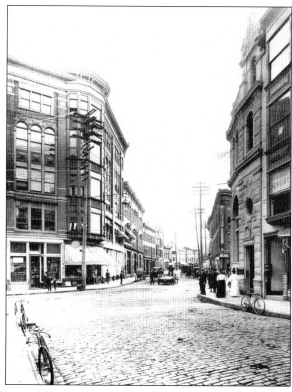

THE SHANNON BUILDING, 1898. Built as investment real estate in 1891, the Shannon Building had first-floor storefronts and apartments on the upper floors. Many downtown office workers, retail clerks, and even professionals lived in the downtown. The building was destroyed by fire in 1909. Its 1910 replacement was built with fireproof construction. (Courtesy the Otis Library.)

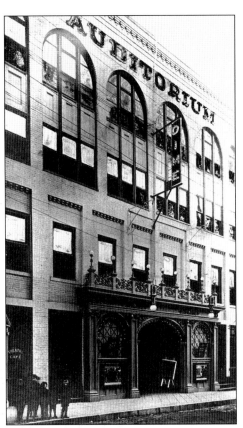

THE ENTRANCE TO THE AUDITORIUM THEATRE. In another venture near his original operation on Water Street, James B. Shannon built the Auditorium Theatre in 1905, later renamed the Strand. In 1915, he built a five-story hotel, the Auditorium Hotel, of fireproof design. The buildings were demolished in the 1960s as part of redevelopment. (Courtesy the Otis Library.)

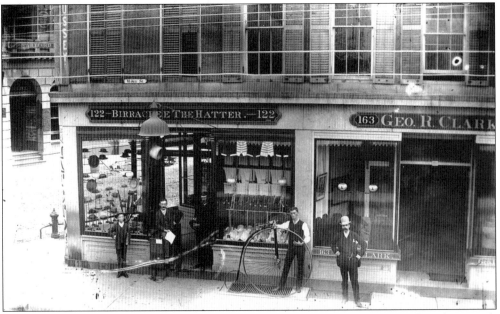

THE BIRACREE HAT SHOP. Taken before the 1909 Shannon Building fire, this photograph shows the store of another Irish American. It was taken from an upper floor of the Norwich Savings Society. (Courtesy Faith Jennings.)

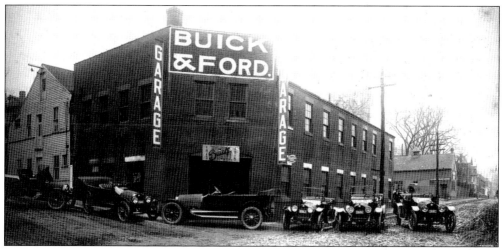

THE IMPERIAL GARAGE, 1915. In the 20th century, automobiles took the place of horse-drawn vehicles for personal travel. Dealerships, garages, and repair shops began to displace livery stables and blacksmith shops. The physical location of the new businesses was virtually the same as the old. This garage and dealership, owned by Peter Ceccarelli, is on the corner of Chestnut and Willow Streets. Behind the building, on Chestnut Street, is the O.H. Reynolds livery, with a carriage parked in the side yard. (Courtesy Faith Jennings.)

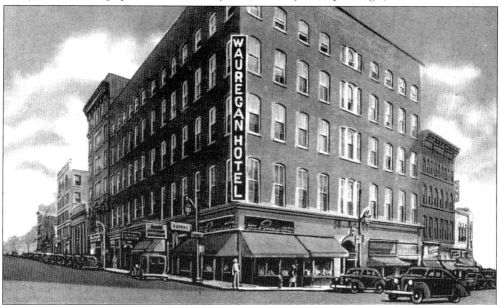

THE WAUREGAN HOTEL, THE 1940S. Another consequence of the automobile age was a change in style. In the 19th century, most people walked. As they strolled through the downtown or a neighborhood, they were very conscious of the ornate detailing on businesses and homes. With widespread use of the automobile, however, vision was restricted to a more horizontal plane. The increased speed of travel allowed much less time to appreciate detail. Simplification and streamlining became hallmarks of 20th-century style. Victorian detail was denounced as excessive and wasteful. In the 1940s, the Wauregan was stripped of its elaborate cast iron window hoods and cornice. Advertisements now boasted of the new, modern hotel. (Courtesy the Otis Library.)

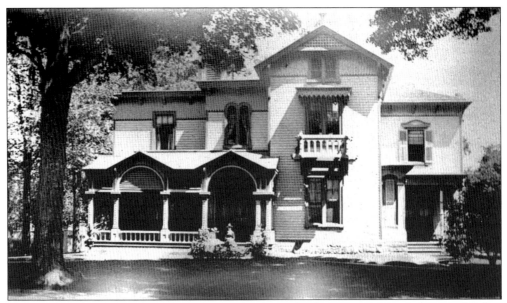

THE C.C. JOHNSON HOME, 1886. At 249 Broadway, this house was extensively remodeled in the early 20th century. (Courtesy the Otis Library.)

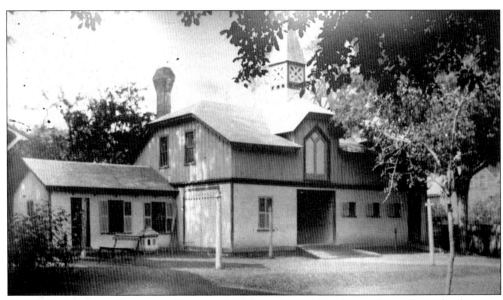

THE C.C. JOHNSON CARRIAGE HOUSE. This Victorian carriage house fronted on a back street. It no longer exists. (Courtesy the Otis Library.)

C.C. JOHNSON WITH HIS FAMILY. C.C. Johnson was the secretary and treasurer of the Norwich City Gas Company. This photograph was taken on the side porch of his home on Broadway. The two women with him are probably his wife and widowed mother.

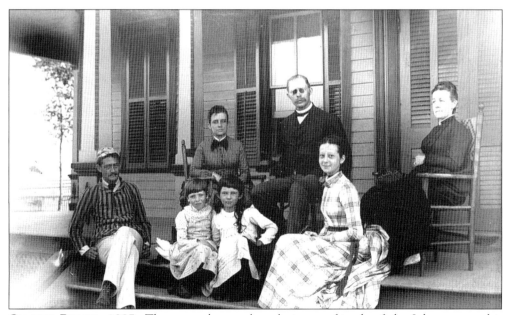

ON THE PORCH, 1887. These people may be relatives or friends of the Johnsons, as this photograph was found in the Johnson album next to a family portrait.

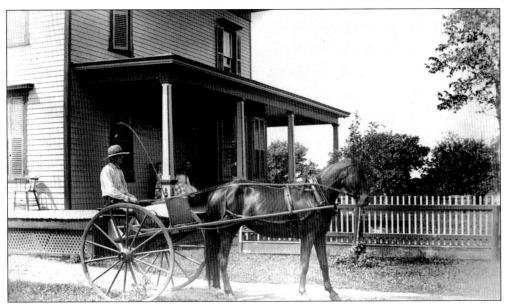

A MAN WITH A HORSE AND BUGGY. This photograph was taken outside the house shown in the previous photograph. (Courtesy the Otis Library.)

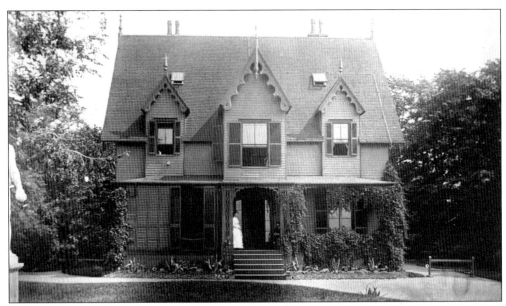

A HOUSE ON SACHEM STREET. This house is an excellent example of the Gothic Revival style. The dormers, decorative bargeboards at the eaves, and the scroll-cut porch decoration all display the quality of design and craftsmanship found in Norwich. (Courtesy the Otis Library.)

THE DAVISON FAMILY, C. 1903. John H. Davison Jr.; his wife, Edith Louise; and their daughter, Ollie, lived on Lafayette Street near the Yantic Cemetery. His occupation was not listed in 1903, but he had previously worked as a clerk in the Carroll Building downtown.

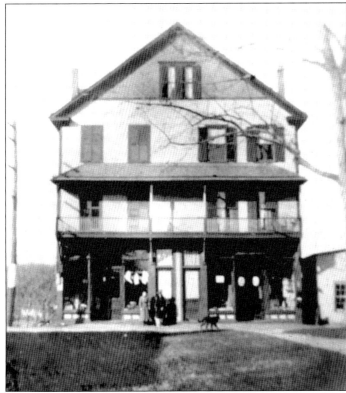

THE DAVISON HOUSE, c. 1903. This house had two storefronts on the first floor. The Davisons lived over the store.

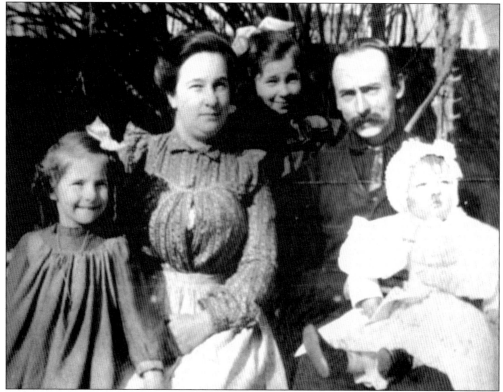

THE MAY FAMILY, C. 1903. Frank W. May worked for the William H. Davenport firearms company, which had a plant near Central Wharf. Shown with him, from left to right, are Ethel, Nellie (his wife), Lillian, and Frank Jr.

A SMALL GIRL AT A MASQUERADE BALL. Here, Lillian May is dressed up in costume. (Author's collection.)

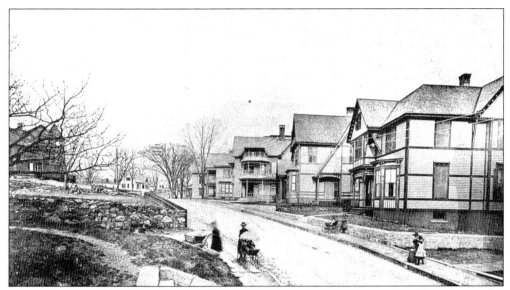

CLIFF STREET, 1888. These houses along Cliff Street were quite new when this photograph was taken. Both the Stick Style and the Queen Anne style were popular. This is a new neighborhood with young couples living here, evidenced by the number of babies in carriages. (Courtesy the Otis Library.)

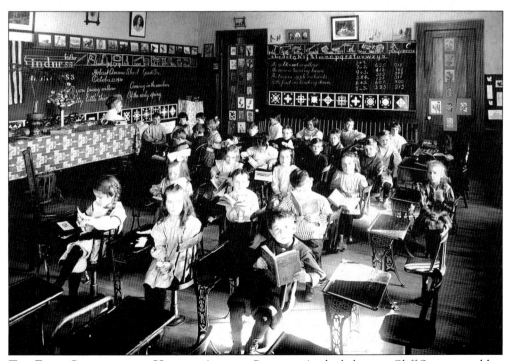

THE FIRST GRADE AT THE HOBART AVENUE SCHOOL. As the babies on Cliff Street got older, they attended the Hobart Avenue School. This photograph was taken on October 25, 1910. The school has been converted to apartments. (Courtesy the Otis Library.)

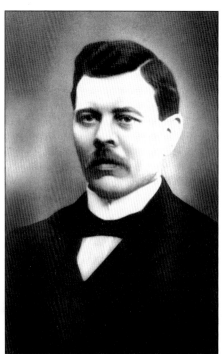

JOHN WATSON LITTLEJOHN. Littlejohn, an immigrant from Aberdeen, Scotland, was a manager at the Reid & Hughes store, known as the "Boston Store," on Main Street. He lived on the West Side. English and Scottish immigrants were often in supervisory or management positions at mills or in businesses.

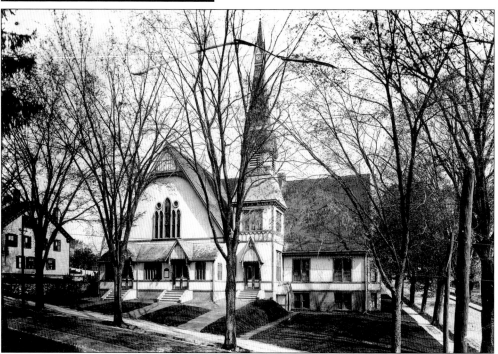

THE FIRST BAPTIST CHURCH. The Baptists were perhaps the fastest growing Protestant denomination in Norwich. The First Baptist Church built an outstanding Gothic Revival on the West Side early in the 1880s. John Littlejohn joined the church. He was soon elected a deacon. After the death of his Scottish wife, he married a American member of the church. (Courtesy Faith Jennings.)

Seven
COMMUNITY INSTITUTIONS

City government in Norwich began with its charter in 1784 as one of the first five cities in Connecticut. The split between city and town was a source of friction through much of Norwich's history. The question of how to best represent the various sections of Norwich is still alive. The existence of separate tax districts with different rates is still an issue in local politics. The Progressive movement in the early 20th century shaped the city in ways still evident today. Private community institutions, however, have done much to create modern Norwich. Immigrants, laborers, and those bonded by particular interests or causes have transformed the social fabric of Norwich. Churches and church-sponsored groups and benevolent and charitable institutions have enhanced the quality of life for local residents.

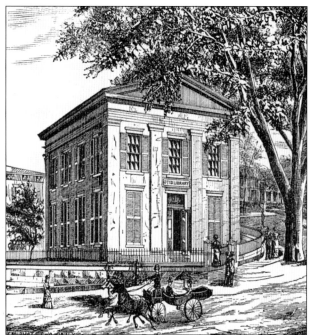

THE OTIS LIBRARY. Opened in 1850, the Otis Library was constructed by retired merchant Joseph Otis. Initially, modest fees were charged for the use of materials. By the end of the century, the library became completely free. (Courtesy the Otis Library.)

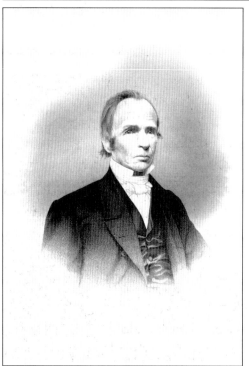
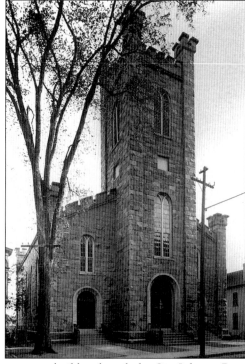

REV. ALVAN BOND. While Joseph Otis gave the money to build and stock the Otis Library, Rev. Alvan Bond was responsible for persuading him to undertake the project. Pastor of the Second Congregational Church nearby, Bond was an activist. The church offered Sunday school for African Americans and welcomed them as members. Bond also opposed the Fugitive Slave Law of 1850. His church was often simply called the Bond Church. (Courtesy the Otis Library.)

JOHN FOX SLATER. The wealthiest man in Norwich, John Fox Slater was the nephew of Samuel Slater, the founder of the American textile industry. He amassed an enormous fortune. In 1882, shortly before his death, he created a $1 million fund for the education of former slaves. His philanthropy was local, too. Fannie Palmer and Emily Davies organized a group of women to provide shelter for the sick and homeless in 1877. Slater and Lafayette S. Foster purchased a house in Norwichtown and presented it to the United Workers, as the new group was known. This was the origin of the Sheltering Arms home. Another benefactor contributed a house on the green that became Rock Nook, a children's home. (Courtesy the Otis Library.)

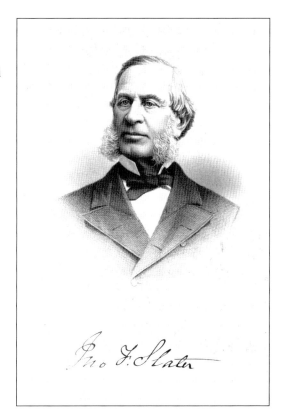

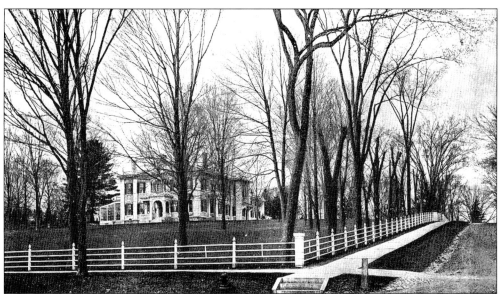

WOODLAWN, THE SLATER MANSION. John Fox Slater could easily afford to dispense charity. At the close of the Civil War, his income was reported as $104,269 a year, millions in today's market. His first mansion was built c. 1843, shortly after his marriage. In the 1860s, he purchased this house and remodeled it stylishly. In 1876, he separated from his wife, building her a mansion up the street. (Courtesy the Otis Library.)

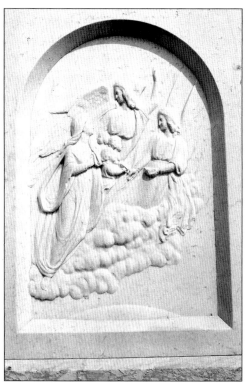

A MONUMENT TO JOANNA BOYLSTON LANMAN. Joanna Boylston Lanman was the wife of Sen. LaFayette Foster. The couple's three children—two girls and one boy—did not survive childhood. Infant mortality struck all classes of society. Here, the three children are shown being presented in heaven by their mother. (Photograph by the author.)

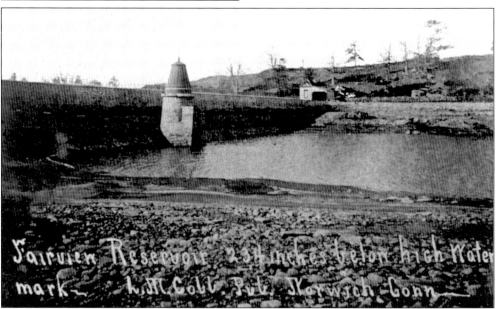

THE FAIRVIEW RESERVOIR, 1888. Perhaps the greatest single improvement in the lives of Norwich citizens was the construction of adequate reservoirs and sewers. Waterborne diseases such as typhus claimed the lives of many, especially the young. The city began construction of the reservoir in 1868. In the two years it took to build, not a single life was lost. The completion of the waterworks was celebrated with a parade on May 12, 1870. This view is of the reservoir during a drought. (Courtesy the Otis Library.)

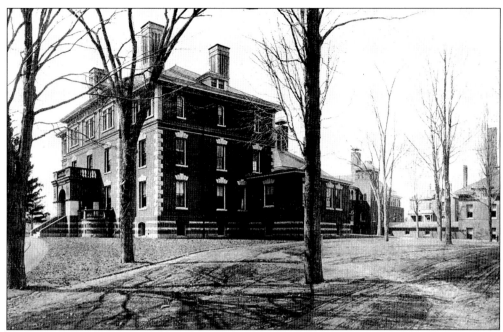

THE WILLIAM W. BACKUS HOSPITAL. The William W. Backus Hospital filled a serious gap in the care of the sick in Norwich. While the Sheltering Arms acted as a hospital, taking in the ill and homeless, it was inadequate for the needs of Norwich's growing population. Private benefactors William W. Backus and John Fox Slater provided much of the backing needed to establish the new hospital, which opened in 1893. (Courtesy the Otis Library.)

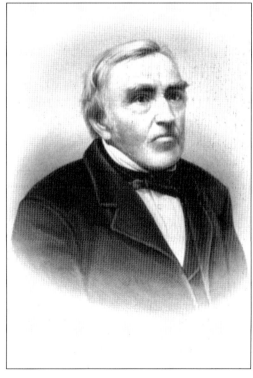

WILLIAM W. BACKUS. Backus was a farmer and cattle dealer who lived in Norwich his entire life, except for a year spent in Ohio. In 1882, it was said that he, during a 50-year career, bought and sold more cattle in New London County than anyone else. Frugal, he amassed a considerable fortune for the day. His total donations to the hospital totaled almost $140,000. He died before the hospital was completed. (Courtesy the Otis Library.)

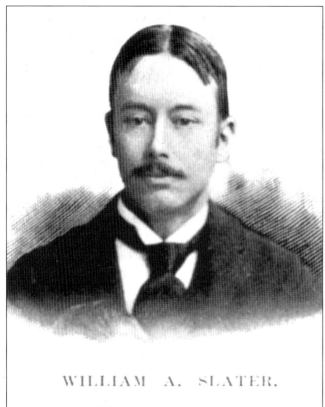

THE LITTLE PRINCE. William Albert Slater was the son and heir of John Fox Slater. Workers at the Slater mill in Jewett City referred to him as "the little prince." He was president of Ponemah Mill during the important expansions of 1884 and 1902. Slater gave generously to the community. Beginning with the Slater Memorial in 1886, he also gave generously to Park Congregational Church, the YMCA, and the Broadway Theatre. His contributions toward the William W. Backus Hospital totaled $370,000. His efforts to establish a normal school for teachers in Norwich were rebuffed. The decision to name the new hospital after William W. Backus was supposedly a factor in his decision to leave Norwich. (Courtesy the Otis Library.)

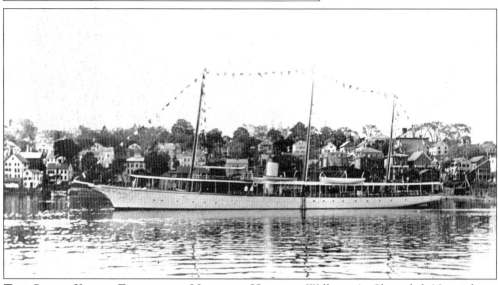

THE STEAM YACHT ELEANOR IN NORWICH HARBOR. William A. Slater left Norwich on October 27, 1894, in his new yacht, *Eleanor,* named after his daughter. Built in Bath, Maine, the ship was intended for a round-the-world cruise. It was 240 feet long overall with a 32-foot beam. Powered by two boilers, the ship carried a crew of 40. The cruise took 13 months. On arriving back, Slater and his family stayed in Norwich for a year and then left for good. (Courtesy the Otis Library.)

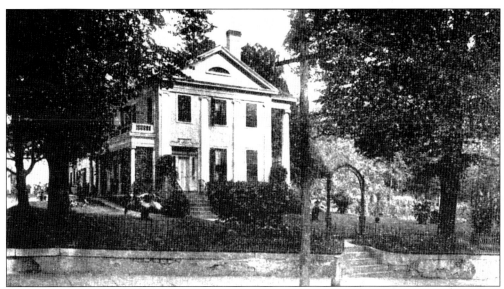

THE ELIZA HUNTINGTON MEMORIAL HOME. Jedidiah Huntington, a lumber and coal merchant, bequeathed his residence to create a home for "respectable and indigent, aged and infirm Females." His wife, Eliza Huntington, who died before him, had expressed the wish that whatever she would have received upon his death be set aside to create the home. (Courtesy the Otis Library.)

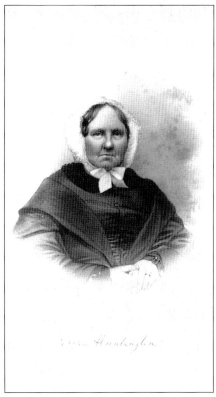

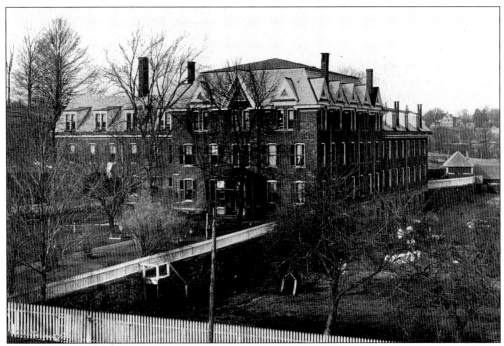

THE ALMSHOUSE. The city almshouse was on Asylum Street overlooking Yantic Cove at the mouth of the Yantic River. Before the mid-1800s, almshouses were used to store the insane, the blind, and others besides the poor. (Courtesy the Otis Library.)

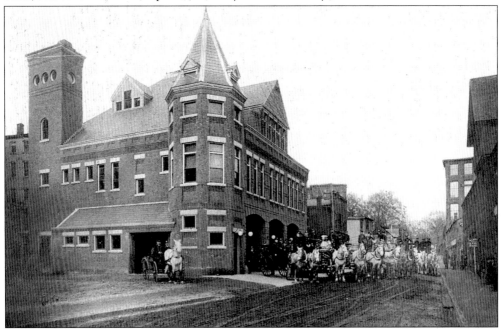

THE CENTRAL FIREHOUSE. The Central Firehouse was built in the Queen Anne style in 1902. The densely built downtown needed additional protection. Toward the rear of the building is a square tower for drying fire hoses. The inside was furnished with beds for the fire crews and the traditional poles for sliding to the first floor. (Courtesy the Otis Library.)

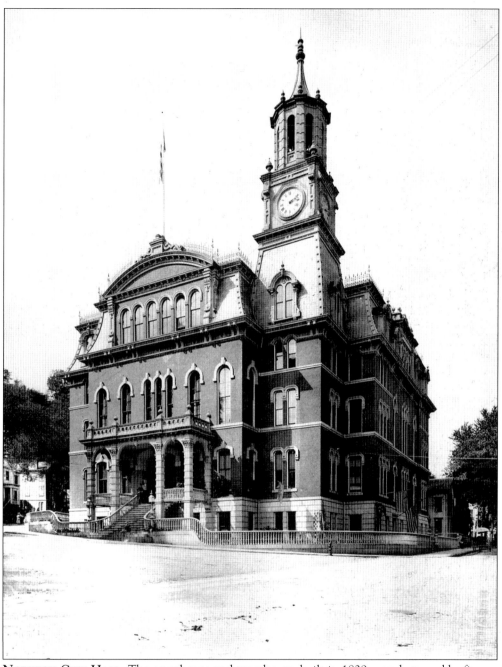

NORWICH CITY HALL. The courthouse and townhouse, built in 1829, was destroyed by fire on April 11, 1865. Only a few days later, Pres. Abraham Lincoln was assassinated. The local legend, still heard today, is that the courthouse, where Lincoln had spoken in 1860, was destroyed the same night as the assassination. The new city hall and county courthouse occupies a dramatic site at the north end of Union Square. Construction began in 1870. Local architect Evan Burdick designed the new city hall in the elaborate French Second Empire style fashionable then. Local craftsmen constructed the building. Even the furniture was made locally, by Nathan S. Gilbert. (Courtesy the Otis Library.)

MAYOR CHARLES F. THAYER. In the first decade of the 20th century, Charles F. Thayer was a major force in city government, operating on Progressive principles. His major accomplishment as mayor was the purchase of the gas and electric company and its production and distribution facilities. Norwich is one of a small number of municipalities in the state that owns the public utilities. (Courtesy the Otis Library.)

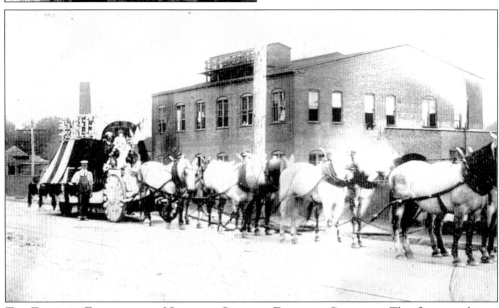

THE ELECTRIC FLOAT OF THE NORWICH GAS AND ELECTRIC COMPANY. This float was driven in the 1901 Old Home Week parade. Two separate companies, one gas and one electric, had merged. In the 1850s, rival companies laid separate gas lines in the streets. Crews would undo the work of their competitor. At the turn of the century, the Progressive movement called for public ownership of utilities. This happened, but most often in municipalities.

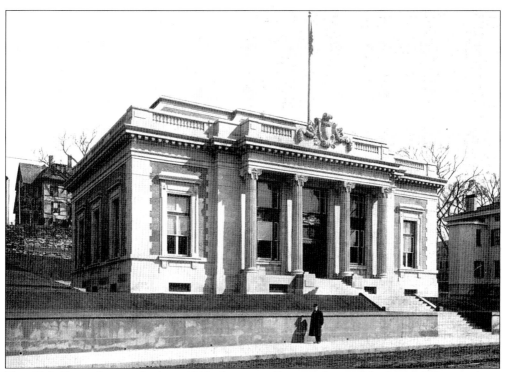

THE U.S. POST OFFICE. Built in 1905, the post office was designed by Louis A. Simon, later supervising architect for the U.S. Treasury Department. The building is on the site of the former Hubbard mansion, which was demolished. (Courtesy the Otis Library.)

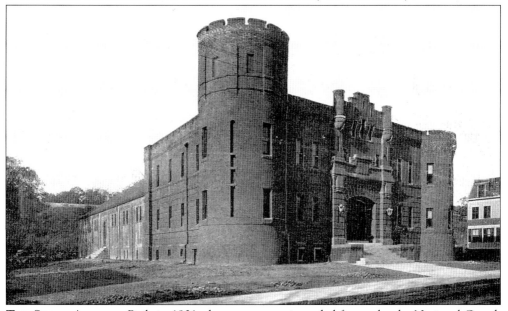

THE STATE ARMORY. Built in 1901, the armory was intended for use by the National Guard, a descendant of the Colonial militia. Armories were deliberately located near urban centers to deter possible riots or labor unrest. In actuality, the armory was used more for traveling shows and exhibits. (Courtesy the Otis Library.)

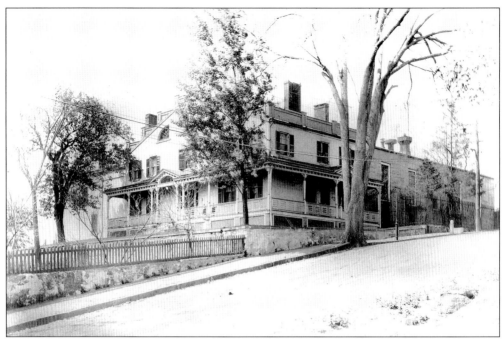

THE NEW LONDON COUNTY JAIL. The first county jail in Norwich was in Norwichtown. In 1833, the courts were transferred to the new courthouse downtown. A new jail was constructed on the hill above the courthouse. This burned in 1838 when a prisoner trying to escape set the jail on fire. The front of the jail was a house for the jailer and his family. Attached to the rear of the house was a stone cellblock. A factory was built next door for the production of leather industrial belting with prison labor c. 1870. The factory soon burned down. (Courtesy the Otis Library.)

THE STATE TUBERCULOSIS SANITARIUM. Established by the state for patients with tuberculosis, the location of the campus on a hill near the Thames River was thought to be conducive to recovery. The name of the sanitarium was later changed to Uncas on Thames. (Courtesy the Otis Library.)

Eight
NORWICH CELEBRATIONS

With almost 350 years together as a community, Norwich residents have celebrated many times, including celebrations for the completion of the waterworks, the passage of important legislation, and the end of wars. Some celebrations are annual and recurring, like the Fourth of July parades. Others take place only once. Celebrations build a sense of solidarity within the city. Anniversary celebrations of the founding of the city can unite people. In a society where fissures over nationality, race, religion, and values seem prevalent, it is important to find common ground. These celebrations, whether for a few hours or a few days, affirm a collective identity as citizens of Norwich and of the United States.

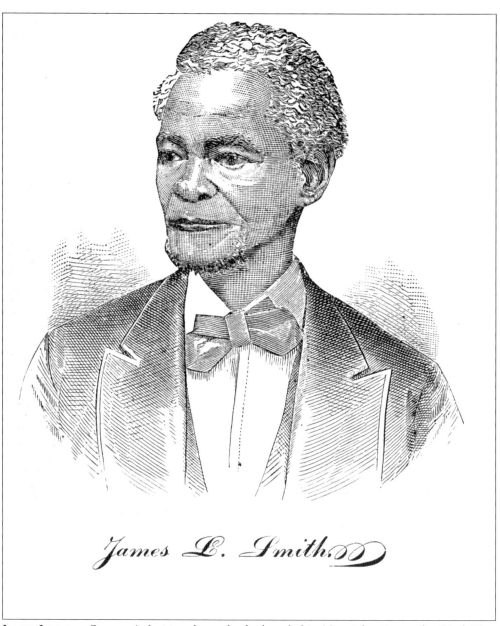

JAMES LINDSAY SMITH. A fugitive slave who had settled in Norwich prior to the Civil War, James Lindsay Smith was a minister and shoemaker practicing his trade on Franklin Square. When the Emancipation Proclamation was issued, he said, "it sent a thrill of joy through every avenue of my soul." On January 2, 1863, the mayor, James Lloyd Greene, ordered a 100-gun cannon salute fired in honor of the Emancipation Proclamation. This was followed by the continuous pealing of the church bells of Norwich for an hour. The passage of the Fifteenth Amendment, which gave voting rights to African Americans, was celebrated on June 16, 1870. A parade from Franklin Square to Rockwell's Grove was followed by a speech from a celebrated black orator, Charles L. Remond. Refreshments were served afterward. The selectmen, common council, clergy, and ordinary citizens attended. (Courtesy the Otis Library.)

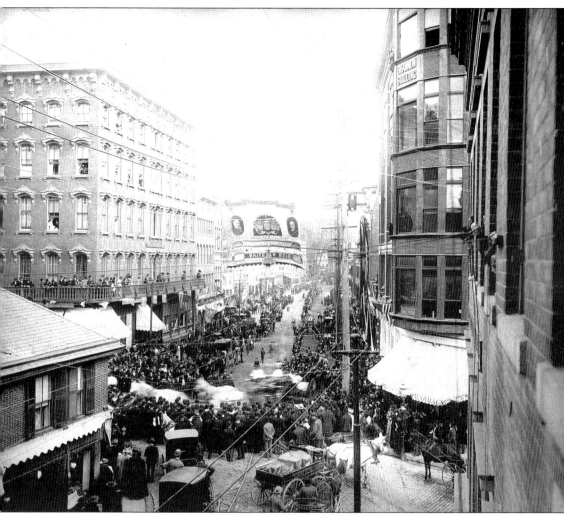

A PRESIDENTIAL CAMPAIGN PARADE, 1892. Parades were a frequent ingredient in presidential campaigns of the 19th century. The corner of Main, Shetucket, and Union (now Broadway) Streets was an important focal point for these events. Here, spectators watch from the balcony and upper stories of the Wauregan Hotel as the parade turns the corner. This parade was in support of the Republican candidates for president and vice president, Benjamin Harrison and Whitelaw Reid, respectively. Their opponent was Grover Cleveland, who had already served a term as president from 1885 to 1889 but had lost to Harrison in the election of 1888. In 1892, Cleveland won. Norwich residents, whether Republican or Democrat, took pride in the fact that Cleveland's ancestors had lived on Bean Hill in Norwich. (Courtesy Faith Jennings.)

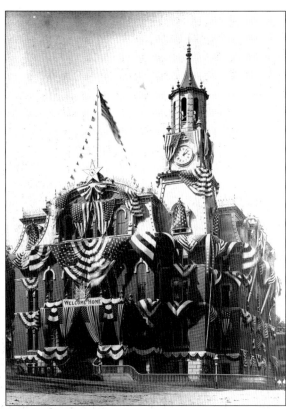

OLD HOME WEEK, 1901. The idea of Old Home Week started in New Hampshire. The governor of New Hampshire began the practice in 1899 by inviting former residents who had moved elsewhere to return for a celebration. Communities throughout New England quickly embraced the notion. In fact, the bicentennial celebration in 1859 adopted the theme, too. This was an opportunity to celebrate the accomplishments of those who had moved elsewhere and to show off the improvements made in Norwich. Here, the city hall is festooned with bunting for the occasion. (Courtesy the Otis Library.)

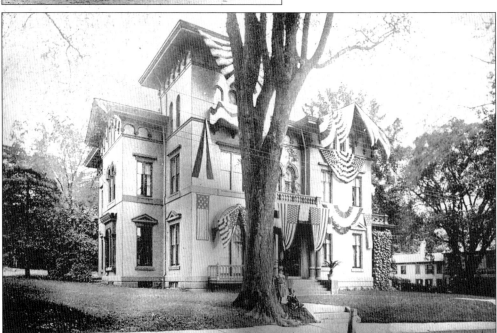

THE HOME OF MAYOR CHARLES F. THAYER, 1901. Private residences, public buildings, and businesses were liberally draped with patriotic symbols for Old Home Week and other public celebrations. (Courtesy the Otis Library.)

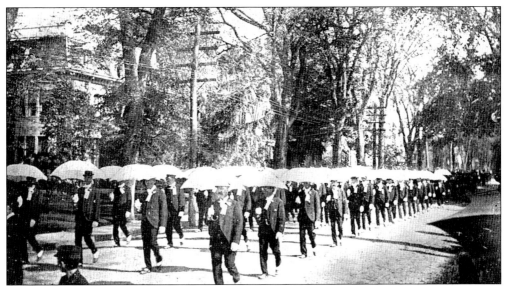

ST. JOSEPH'S SODALITY AND LITERARY ASSOCIATION. This was a Roman Catholic men's group, or confraternity, devoted to prayer. From the roster of officers, it seems that the society's members were Irish Americans. (Courtesy the Otis Library.)

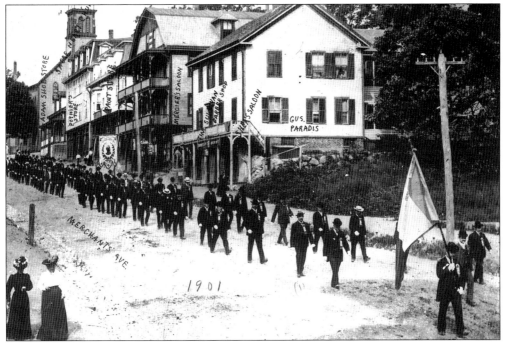

ST. JEAN-DE-BAPTIST SOCIETY PROCESSION, JUNE 24, 1901. Taftville celebrated its own special occasions. The St.-Jean-de-Baptist Society was a men's group affiliated with the Sacred Heart Church. Named in honor of the patron saint of Quebec, members of the group paid $1 each to the family of any member who died. This death benefit could add up to $100, depending on the size of the membership. The society was also closely identified with French nationalism. The flag borne in front of the procession is the tricolor French national flag. (Courtesy Rene L. Dugas Sr.)

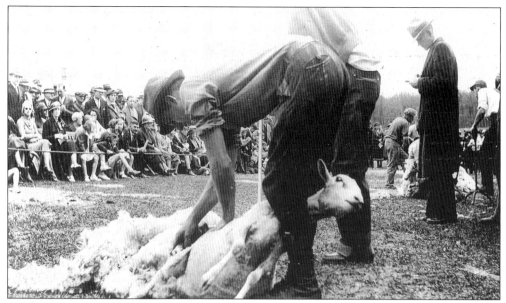

SHEEPSHEARING, 1935. In 1934, local residents celebrated the 150th anniversary of the incorporation of Norwich. The next year, the 300th anniversary of Connecticut was the focus. Dr. Ier J. Manwaring, a pioneering woman physician, held a sheepshearing festival on the grounds of her house in the East Great Plains section. Dressed in Colonial uniforms, the Mattatuck Drum Corps of Waterbury performed. (Courtesy Diane Norman.)

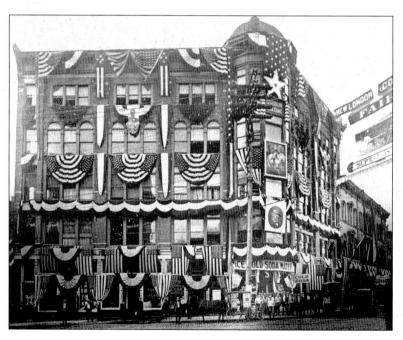

THE SHANNON BUILDING, 1901. The Shannon Building was in a premier location, readily visible to all. The flagship of his real estate empire, James B. Shannon took justifiable pride in the appearance of the building. (Courtesy the Otis Library.)

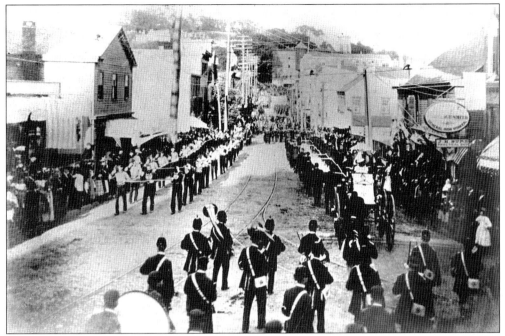

THE QUARTER MILLENNIUM CELEBRATION. In 1909, Norwich celebrated its 250th anniversary. President Taft was invited, and he accepted. The celebration lasted for three days, from July 4 to July 6, 1909. The centerpiece of the celebration was a gigantic parade with floats representing various businesses, mills, and organizations. It was similar to celebration of 1901. (Courtesy the Otis Library.)

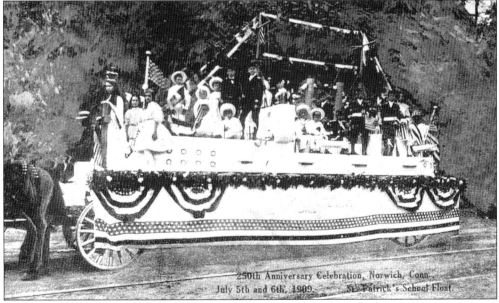

ST. PATRICK'S PAROCHIAL SCHOOL FLOAT, 1909. Students in naval uniform man this remarkable float, in the form of a battleship. Memories of the Spanish-American war were still fresh. There was intense pride in the one-sided victories of American warships over Spanish fleets in the Pacific and the Caribbean. (Courtesy Faith Jennings.)

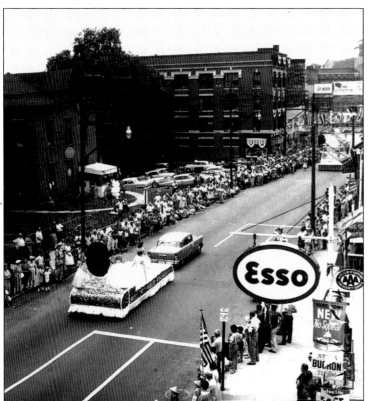

THE TERCENTENARY PARADE, 1959. For its 300th birthday, Norwich held a party that lasted a week. A historical pageant featured a cast of more than 700. For the show, men grew beards and mustaches and women donned bonnets and dresses. Festivities included a simulated atomic bomb explosion, complete with mushroom cloud. The parade featured floats like this one from Ponemah Mill. The mill proudly shows the fine cloth that was its product. (Photograph by, and courtesy of, Faith Jennings.)

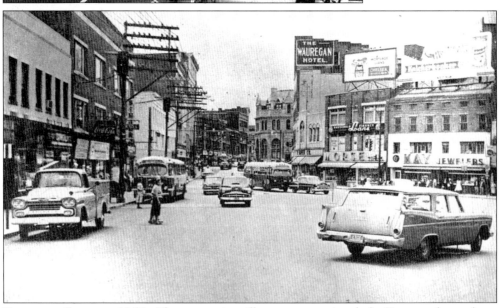

FRANKLIN SQUARE, 1959. The square is still a transportation hub. Buses and cars have replaced the trolleys and horse-drawn vehicles. The fountain for watering horses has been removed. The downtown is still thriving, but the wind of change is coming. Highway construction and redevelopment are happening and will have a tremendous influence on Norwich. (Courtesy the Otis Library.)